8º

kokoschka

kokoschka

Giuseppe Gatt

Hamlyn
London New York Sydney Toronto

twentieth–century masters
General editors: H. L. Jaffé and A. Busignani

© copyright in the text G. C. Sansoni, Florence, 1970
©copyright in the illustrations Cosmopress, Geneva, 1970
© copyright this edition The Hamlyn Publishing Group Limited 1971
London · New York · Sydney · Toronto
Hamlyn House, Feltham, Middlesex, England
ISBN 0 600 35305 2

Printed in Italy by: Industria Grafica L'Impronta, Scandicci, Florence
Bound in Italy by: Poligrafici Il Resto del Carlino, Bologna

Distributed in the United States of America by Crown Publishers Inc.

contents

List of colour illustrations

List of black-and-white illustrations

Kokoschka and Expressionism

Oskar Kokoschka is usually said to be one of the artists who gave life and meaning to the Expressionist movement in Germany, and rightly so, although he did not officially belong to either the Brücke group or the Blaue Reiter. We shall therefore examine his work – and the connections between the various art forms he practised: poetry, the theatre, essays and the figurative arts – within the context of Expressionism and its ideas. Obviously this means first taking a look, if only a very general one, at what Expressionist culture was, and the historical and social factors that formed it.

Expressionism might be defined as the culture of man in revolt, man at such a pitch of conflict with the world, and in such a purely negative condition with regard to it, that he could express himself only in a way which would not evolve naturally, which was forced to an abrupt end. It was a brief, intense movement, quickly exhausted, and many Expressionists died young, either killed in the First World War or committing suicide, and often leaving behind them work that was unfinished or immature. But the 'anger' of the Expressionists was not entirely abstract. Some of it expressed their reaction against the positivists of the second half of the nineteenth century, some was the typically northern European love of rebellion, which, invoking an intensely desired freedom, opposed the rational, harmonious balance of southern, Mediterranean Classicism with destructive violence. It was born from a national rejection of the bourgeois vision of the world; and historically, it was precipitated by the First World War and the political and social events of the Weimar republic and its failure. The whole of Europe was involved in this situation of historical and political crisis, which, in art, expressed itself as the desperate conflict between reality and the individual, between lyricism and public passion, between Eastern mysticism and the activist ideology of the West. There was astonishment, too, at the scientific and technological discoveries of the age; infinite bewilderment at the use industrial capitalism was making of them. There was a wild longing to hit out at whatever was bureaucratic, mechanical and militaristic; and, finally, a longing to find new, shared spiritual values, after wiping out the past which, politically, meant the dominance of great empires, and, artistically, meant the dominance of Impressionism.

In other words, the revolt against the world was essentially one against the bourgeois world of order, respectability, hierarchy and social climbing – in practice that of the Germany of the Emperor Wilhelm and of Bismarck, which European artists of the day had inherited from their fathers and which had thrust them into war. On the one hand, those involved in the revolt realised that it had a historical meaning and that man must be seen in a

**Denial
of the bourgeois
outlook**

7

particular social context; on the other, it had nothing to do with history, and saw man in a universal cosmic light, as one able to bring about a renewal of humanity quite outside the context of everyday, something that would be achieved through superhuman sacrifices. This was the concept of redemption through suffering, which was derived from Dostoievsky, and the most powerful dramatic Expressionists, such as George Kaiser (*The Burghers of Calais*, 1914), Jakob Wassermann (*Christian Wahnschaffe*, 1919), Paul Kornfeld (*Heaven and Hell*), and Fritz von Unruh (*A Generation*), kept returning insistently to it.

It was not by chance that the Expressionists did not seek to make their protest in a city, that is, in the natural product of historical man, but in nature, which was insensible, infinite, and dominant: an expression of what is eternal in the world. Later we shall see how these two contrasting aspects of Expressionism – a kind of 'to be or not to be' – were summed up in the two groups known as the Brücke and the Blaue Reiter. And these many influences, uniting with extreme intellectual toughness to produce Expressionism, gave rise to an internal paradox within the movement itself: it worked through dialectical antitheses, it was unable to find a common way of thinking, and as a result, it is impossible to define a homogenous course that in some way is common to its protagonists. Expressionism had no philosophy of its own and could not be linked with any single philosophy; it had no exact programme or theory or exactly formulated ideological ideas. Formally, too, it almost entirely lacked interest in the formation, development or analysis of a style: all the Expressionists were trying to do was create a new style that would go beyond the mechanically sensuous and merely visual style of the Impressionists: a style that might, of course, include a good measure of violence within itself. Indeed, while French Post-Impressionism (and Fauvism, which ran parallel to it, and was a movement of luminous seeking, dominated by an uncontrolled, excited use of colour) was rejecting traditional forms and techniques in order to discover new dimensions in art, Expressionism was using forms emotively, subordinating them to the content of the work.

Psychological and social factors were far more important than aesthetic ones, indeed they were used in such a way that forms were actually shattered in an effort to find the profound or hidden significance which might be hiding behind the appearances of things. The relationship between seeing and visualising which the Impressionists had built up, was overthrown; the Expressionists went back to the very sources of fantasy and visualised what they felt, or perhaps what they saw, not externally but within their own minds.

Fall and salvation

Expressionism inherited Van Gogh's exalted, mystical participation in the soul of things, the introspective Ensor's intense, tumultuous imagination, Gauguin's rhythmical sense of colour and, above all, Edvard Munch's obsessional spiritual morbidity. It was Munch's *Howl* in 1893 that can be considered the emblematic manifesto of the Expressionist 'shout'. In this desperate emotional intensity, the Expressionist artists were confused and alienated, possessed by inexhaustible excitement and whipped ahead by forces far beyond them, forces that bewildered and overwhelmed them. Romanticism had already suggested these attitudes and Turner had emphasised the perpetual dynamism of nature. The works of the Expressionists show what, in Bergson's creative evolution, is called 'fallen', that is, the crystallisation of the vital impulse. But the Expressionists, in seeking something sacred that could not be recovered, flung themselves into action as an end of itself, obsessive action that had no outlet and condemned itself to failure. This idea of a fall produced the moral attitudes of Expressionism. For, since man and history are involved in the fall, it is there that the chance of salvation must be sought. The most direct way of going into history while contesting the present is to look for tradition: Barlach rediscovered Romanesque sculpture, Beckmann carefully exploited Grünewald, in

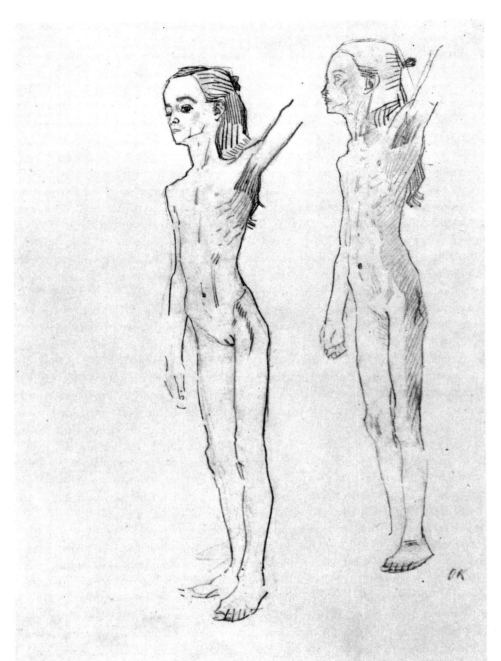

graphic art the Expressionists discovered the style of German medieval art and in technique the origins of the craftsmanlike popular German *Volksgeist*.

On the other hand, the grafting of an earlier culture on to their own meant that they moved beyond the motives that had inspired Van Gogh, Ensor, Hodler and Munch. The rediscovery of tradition (and, more precisely, of popular tradition) meant that Expressionists were open to all kinds of anonymous group influences, and that the artist identified himself with collective ideas. It was another of Expressionism's moral principles that the salvation or the perdition of the whole of humanity was synthesised in the individual man, indeed, that in the contemporary world a man expressed himself as an individual. This made the Expressionist artist subjective in an angry, absolute way; as he was a synthesis of human destiny both individual and collective; the artist, just because he was a creator, must struggle for himself and for others, must suffer several times over. This meant that human life must essentially be dealt with on an ethical level before it was solved on an aesthetic one; the artist must take wary note of the world, and must feel and act in such a way that he has an active moral choice. And since choice – in Kierkegaard's sense of the term – poses the problem of existence before

it reaches knowledge, art must mean existence, awareness, and choice. But in order to feel awareness – complete awareness – aesthetic activity must first of all know exactly what it meant by its own terms. So Expressionists were introspective, plunging into the sulphurous unfamiliar depths of the unconscious, and lured by the darkness where terrible visions might reveal their secrets.

To bring all this to the level of consciousness; to give a meaning to the primal formlessness and darkness of things; to lay bare the most secret vices, to show up on the body the most far-fetched, the most destructive corruptions of the soul; to·exist in a present dimension that was known in every detail; to dare the night terrors and dreary gloom in which ancient German mythology was steeped; to 'feel' rather than 'see'; and, when one looked, to look with the eyes of the soul, visionarily: all this meant 'to express'.

The Brücke group Expressionists showed this typically German sense of predestination and rage; the painters in the Blaue Reiter group tended to be more critical, to control the forms they used more strictly, and to come closer to the abstract ideas of the rest of Europe at the time, ideas that became more and more introspective and saw things more and more with the mind. Space, as well as materials, concerned them, and this concern meant the end of the figure, iconographically observed. It might be said, then, that the Blaue Reiter group represented what was reflective and intellectual in Expressionism, its idealistic tradition; and the Brücke group showed the unconscious and the visionary in it.

Iconology of the emblem

The two groups had not only similar influences behind them but similar aims. It has been said that Expressionism sought to show collective problems; the Blaue Reiter, then, logically as well as chronologically, was the second

2 Papa Hirsch
1907, oil on canvas
$26\frac{3}{4} \times 24$ in (68 × 61 cm)
Neue Galerie der Stadt
Linz, Linz

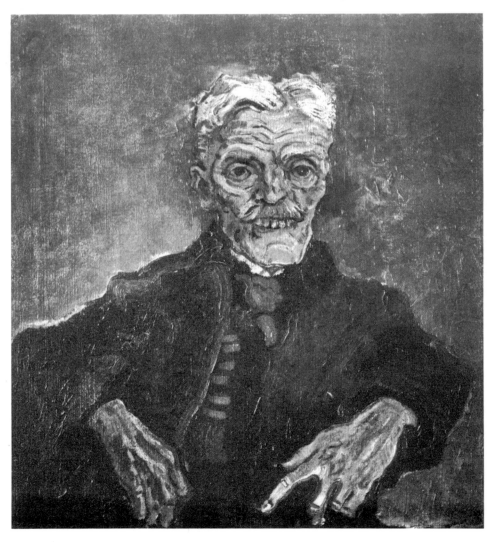

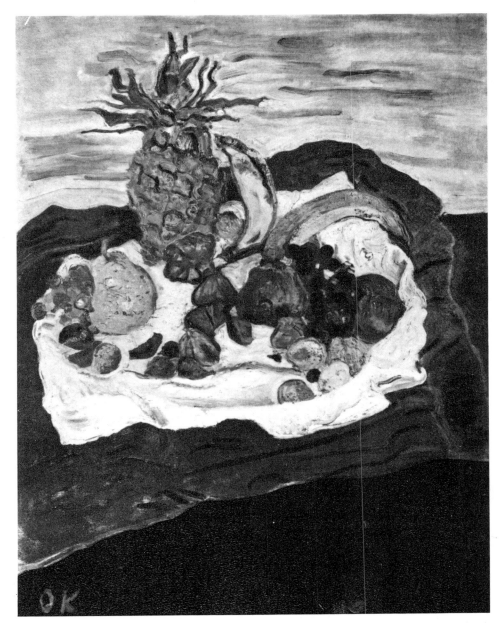

3 *Still-life with Pineapple*
1907, oil on canvas
$43\frac{1}{4} \times 31\frac{1}{2}$ in (110 × 80 cm)
Former State Museums,
Berlin–Dahlem

stage in this. The Brücke group showed the 'season in hell' through which
a man whose eyes and mind could stand its terrible visions might become a
seer. A clear understanding of social matters is impossible without having
first sounded the collective unconscious; after plunging into the bitter,
deathlike visions of a Nolde or a Kirchner, awareness emerges again, sees
its own terms and its own facts clearly, and finally plans a historical existence.
Kandinsky's book *Concerning the Spiritual in Art* (1912) and his non-figurative
ideas, and the ideas which were being discussed at the time by architects
and artists, show that, although they sometimes appeared through the
delicate, neurotic anguish of a Klee, Expressionist ideas passed through
intellectualism, ideological outbursts and ethical despair to reach a clear
social programme: from 'non-being' to 'being'.

A formal analysis of Expressionism shows what was meant by the image.
The relationship of Expressionist art with the outside world was complex
and contradictory; it excluded it, and participated in it, and there was a
duality between subject and object; at the same time, it insisted on experience
in action, which cut out all duality. Things outside ourselves cannot be
caught or deciphered, merely because they have their own intrinsic,
impenetrable objectivity, which has no humanity about it and is therefore
aggressive; at the same time they also exist in us because we are aware of
them. Man has a dual attitude. On the one hand, he is isolated in fear and
pain and therefore often savage: primordial man seeking a lost sense of
what is holy, desperately rejecting the dimension of the present in order to

recover that of history, and longing defencelessly for catharsis (derived from the Gothic) in a primeval world full of horror and fear and a sense of imminent disaster. On the other hand he knows that unless he is full of awareness (that is, unless he is in the dimension in which he is aware of things) and therefore alive, he cannot ever find the absolute he is seeking.

This inner search is painful, exalted, angry and tragic, a constant struggle between the material and the spiritual, between the will to communicate and the objective state that cannot communicate. In the techniques and forms which the Expressionists used, this struggle was made concrete and factual in the image. Colours explode with a wild tension; the drawing slashes at the subject like a knife-blade; the translation of the idea into an image takes place at the very moment in which the image is technically achieved. It follows that the artist at work has no truck with established styles and conventions, but creates new ones that are relevant to the particular circumstances: form, like colour, is a part of this. Violence of form, wildness of colour, the ghostly quality of line – all these symbolise Expressionist culture. Every action is a conquest; it means salvation through failure. In this existential condition, Expressionism refused to make types and instead sought in particular episodes for the human condition in general, broken under the constant nightmare of tragedy. 'What matters is not the contents of a work' Argan writes, 'but its intrinsic communicability; strictly speaking, the image is merely a structure of communication'. And Kasimir Edschmidt

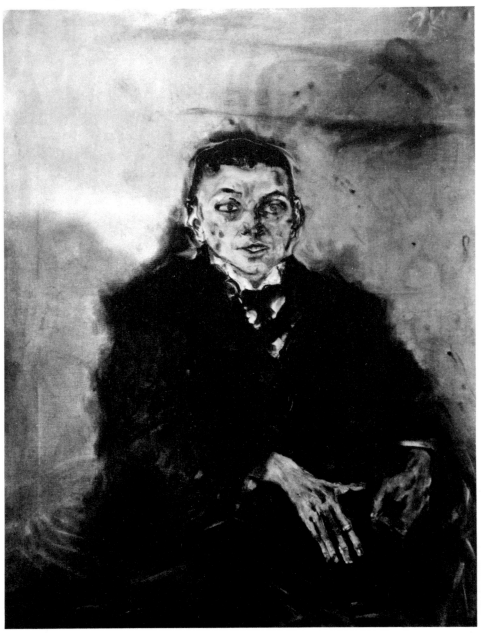

4 *Karl Kraus, I*
c. 1908, oil on canvas
$43\frac{1}{4} \times 29\frac{1}{2}$ in (110 × 75 cm)
Private collection,
Neuss am Rhein

5 *Karl Kraus*
c. 1909, indian ink drawing

says that to the Expressionist, the problems of the individual are used only as reflections of universal problems; and, as these problems can be seen only intuitively, the Expressionist artist cannot 'reproduce' the visible; he must, through an ecstatic vision entirely without naturalism, 'create'.

The refusal to use types does not make the image into a symbol, however. It is always a phenomenon that may be found in ten or a thousand other similar situations, and therefore it becomes emblematical. The images used by the Expressionists (from primitive to civilised man) are, in fact, emblems, that is, forms that immediately suggest their own meaning. The emblem of Expressionism is existence; the existence of man and, at the same time, the existence of the image.

Oskar Kokoschka, as we already said, did not belong to either the Brücke or the Blaue Reiter group. His *Weltanschauung,* one of the most individual and rich in Expressionist culture, first appeared as a reaction to the cultural, historical and social conditions in the early years of the century in Germany

**The values
of life**

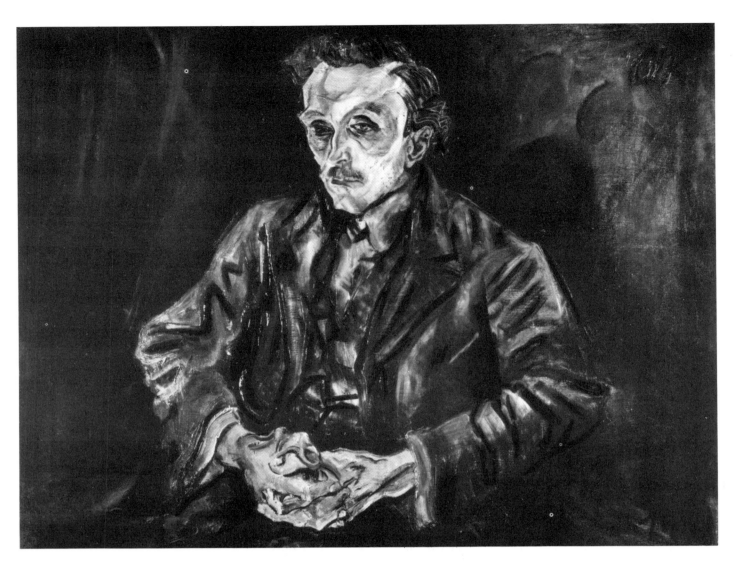

6 *Adolf Loos*
1909, oil on canvas
29 × 36½ in (74 × 93 cm)
Former State Museums,
Berlin–Dahlem

and the countries of the Austro–Hungarian Empire. Materialism was balanced by a longing for romanticism; incipient socialism by the reactionary ideas of the bourgeois and the militaristic. The *belle époque* in central Europe was dying but refused to accept the present, and was drifting, cynically and even sarcastically, towards war. Then, too, there were Fiedler and Nietzsche; Klimt and Schiele using Gothic ideas quite out of their historical context; and Sigmund Freud's analysis of the unconscious.

Kokoschka's own background was as rich and varied. He loved nature and he loved the visionary; he analysed forms with passion and at the same time was violently attached to the external world through images that were always objective. He had a geometrical sense of composition and at the same time 'shouted' uncontrollably. He loved civil liberty and had a feeling for the tragic; humanism and barbarism were combined in him. But, apart from this background, which was shared by nearly all the artists of the time, there were notable differences of style, pictorial method, and even of vision of the world, between Kokoschka and the Brücke and Blaue Reiter groups. A few examples of these differences may throw light on Kokoschka's painting.

Ernst Ludwig Kirchner, spiritual guide, encourager and theorist of the Brücke group (1905–13), and one of its major artists wrote: 'with profound hope in progress, and in a new generation of creators and the public, we call on the entire generation of the young, and, as the young are linked with the future, we want to act in a way that is opposed to what is established and consecrated. Anyone who expresses his own creative impulses honestly and without ambiguity is with us'. This programme clearly shows that the Expressionists considered the possibility of action beyond their own groups, strictly and honestly reacting against the stable, settled past; and

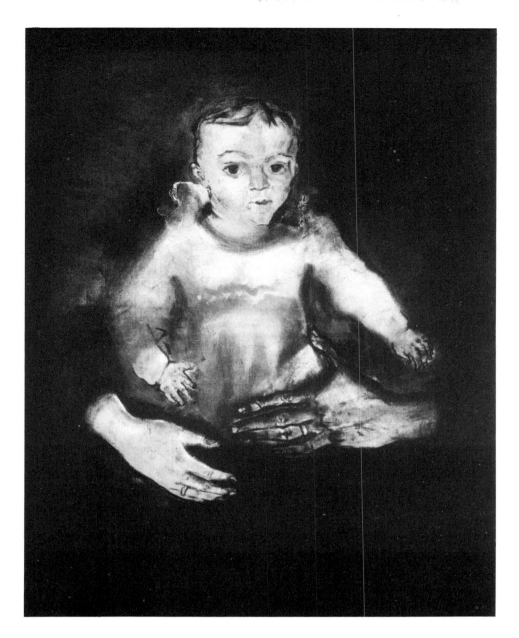

7 *Child with his Parents' Hands*
1909, oil on canvas
$28\frac{1}{4} \times 20\frac{1}{2}$ in (72×52 cm)
Private collection,
Santa Barbara, California

one can also imagine that Kokoschka, who was a writer and thinker as well as a painter, might have preferred individual action, maintaining that he could thus carry out his historical task more efficiently.

Oskar Kokoschka, then, solved cultural problems through artistic means; whereas the Brücke painters were moved by a moral excitement, and had no truck, at first, with artistic matters—which, if anything, were to be a carefully considered result of what was done. Once the historical roots and collective motivations of contemporary art had been established, their main object was to throw a bridge towards the future, and to mobilise and exploit 'all revolutionary elements' in the cause of humanity ('We are no longer painting for art but for man'). Kokoschka was interested in the abstract and the symbolic, as well as the typical and the single, in any human situation; the other Expressionist painters, however, fastened almost entirely on man ('naked man'), considered as an emblem of the human race, with consequent lack of interest in psychological problems. These problems, on the other hand, were of constant interest to Kokoschka, as the series of portraits made between 1907 and 1910 particularly shows, and later portraits confirm.

The same thing can be said for landscape. Kokoschka's landscape is individualised and all his own, with naturalistic touches that might be called impressionistic if it were not that one feels nature has been harshly overturned and the internal composition shaken by the way in which Kokoschka plunges into the depths, and participates intensely in the scene.

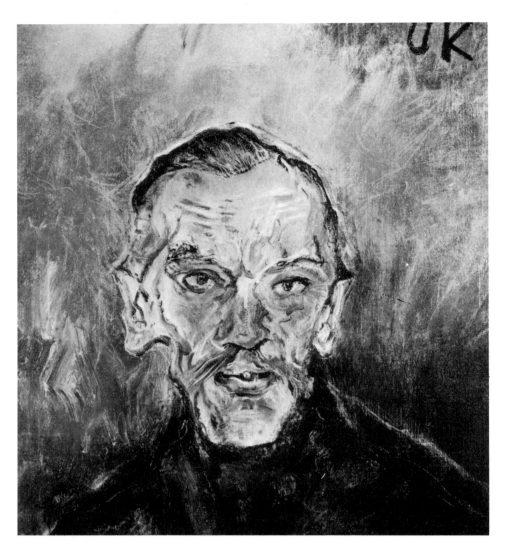

In contrast, Expressionist landscape is anonymous and eternal (as nature is eternal and unchangeable), harsh and shadowy, quite uninterested in the human drama and quite outside it. The difference between them goes deeper than that, however: Kokoschka saw in rebellion the means to stand up and confirm the values of life that were already throbbing in his work, whereas the Brücke painters gave themselves up to a destructive, negative nihilism, a pessimism that saw no hope of redemption. Kirchner developed the process begun by Toulouse-Lautrec, bitterly and disenchantedly demolishing what was left of the *belle époque*; but whereas Toulouse-Lautrec had clung to what was human in his paintings, even though he showed people as weak, wretched, insect-like creatures, Kirchner deprived his people of humanity altogether, and made them tragic puppets, ruled and emptied by forces that overwhelmed them. Kokoschka, on the other hand, tried to keep what was human, in spite of war and revolution. Kirchner had social and popular subjects but, like Heckel and Schmidt-Rottluff, he lost all their humanity, wholly forgetting the moving values of Van Gogh, to which Kokoschka keeps referring, although in a new way.

In graphic art, the differences were not merely those of content, but technical. The Brücke group's woodcuts have lines that are stiff and insensitive to the point of cynicism, crowding into small spaces, and the same themes and images keep recurring in them: old men (that is, humanity weighed down by life), peasants (humanity weighed down by work), prostitutes (humanity weighed down by poverty and degradation); all closed images in a dark and dreary landscape. The lines in Kokoschka's lithographs, on the other hand, are constantly re-invented, faithfully suited to subject, time and place: he had a springing line, which results from the never slackening tension of his imagination, and keeps reappearing, with varying values, in the various subjects he paints. Nolde's orgiastic use

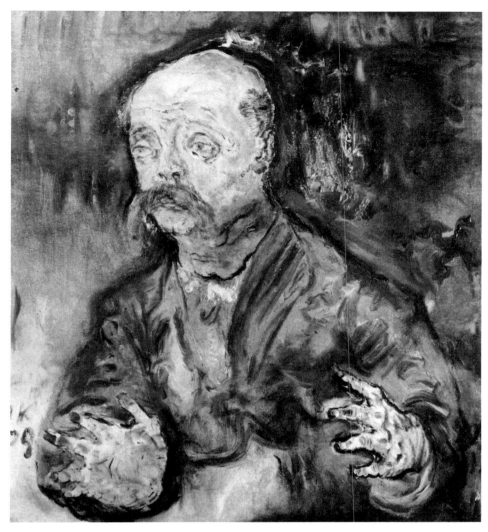

9 *Peter Altenberg*
1909, oil on canvas
30 × 28 in (76 × 71 cm)
Private collection,
New York

of colour and forms, finally, was an expression of Dionysiac barbarism (the carnival of life that ends in death), which can be put down to the vision of a Nietzsche (whose European equivalent in images, though more deeply felt and considered, is Ensor), as well as the savage influences of present-day figurative painting: Nolde's work, apart from certain paintings such as *The Power of Music* (1918–19), is at the opposite extreme from Kokoschka's.

Kokoschka differed from the Brücke, then, in particular because he kept trying to 'recover humanity', trying to 'take humanity away' from the wild barbarism of a vision of the world without hope. (In this, too, he was Nietzschian in the sense of 'human, too human'.) In the same way and for the same reasons Kokoschka also differed from the other side of Expressionism, the lyrical and theoretical side which was represented by the Blaue Reiter group. This group sought to avoid mental freedom by playing intellectual games with the abstract: in other words, theirs was an alienated lack of humanity, or rather of a casual, forgetful *Weltanschauung*. Kokoschka stood on the slippery poetic watershed called 'European', half way between the barbaric and all too human depths of a primeval existence already marked by the indelible stain of original sin, and the rarefied atmosphere of intellectual theorising and escapism, and his deep-laid, obstinate and angry hatred of the abstract (the iconoclastic attack that calls itself "non-objective art"', as he calls it), must be seen in the light of this humanism of his. And there is no doubt that many of the shortcomings of contemporary artists must have seemed to him a result of cutting off contact with humanity: Kandinsky's cosy escapism, lyrical and fairy tale in effect, in his early work; Klee's ambiguous and neurotic linking of his inner world with the objective world; Franz Marc's irresponsible flight to a kindly natural world of animals and plants; August Macke's narrative preciousness, slightly idyllic and

Murder, Hope of Women

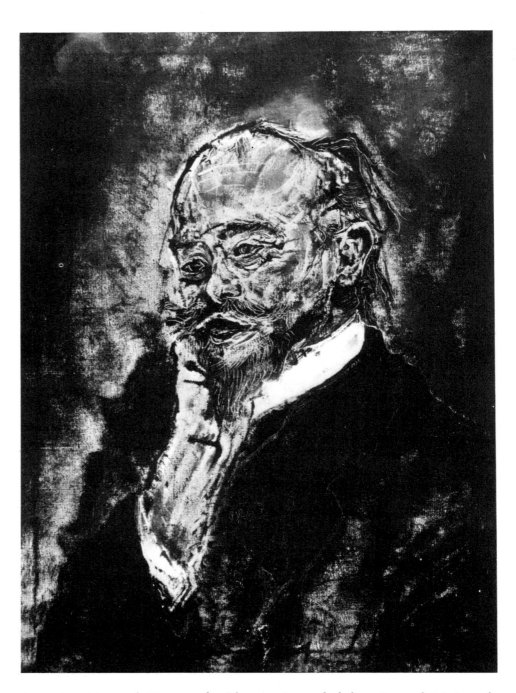

10 *Peter Baum*
1910, oil on canvas
$25\frac{1}{2} \times 18$ in (65×46 cm)
Private collection,
Wiesbaden

Proustian; Heinrich Campendonk's naive improbability; Lyonel Feininger's precious simplicity; Alexei Jawlenski's Fauve colouring charmingly accomplished. Between the activists (who were committed on a social and political plane) and the mystics (who sought for the relationship between God and man), Kokoschka came closer to the mystics: indeed he showed an unshakable faith in a new kind of relationship among men, one of universal brotherliness; indeed, he actually believed in the 'New Man'.

Some absolutely isolated artists, then, like Ensor or Munch, can be included among the Expressionists, and there are also some, like Paula Modersohn-Becker, Christian Rohlfs, Ernst Barlach or Wilhelm Lehmbruck, who are known as 'independent Expressionists'; in the same way Kokoschka can be numbered among them, not just because of his paintings but also, and in particular, because of the ideological, technical and cultural substance of his dramatic work. The publication of *Murder, Hope of Women,* in 1907, in fact settles the argument as to when Expressionism was born, although the Brücke group was founded in 1905 and Kirchner (although he was still close to Fauvism) was already painting in a way that was inspired partly by the late Gothic and partly by the barbaric.

Now, if the Expressionist's vocation is admitted to be part of this world, and the relationship between the artist and the world is made in terms of

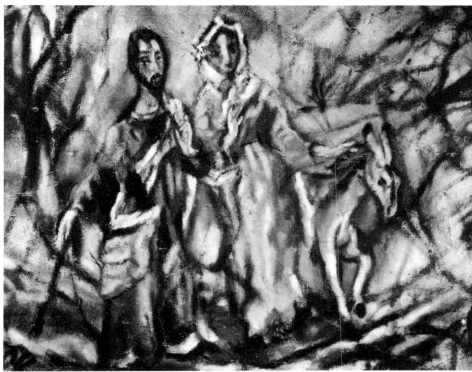

existence, the work of art, which documents the act of existence, must involve the audience as much as possible in the process of existential purification. Under these conditions, the theatre is obviously a form of expression that is not only complete but unique as a means of acquiring awareness.

Another theme that almost contains within itself the particular idea of the world and the human condition as seen by the Expressionists (with their sense of torment and ecstasy, their longing for freedom and their sense of slavery on earth), is the theme of woman: in her, the characteristics of Apollo and of Dionysus, that is, exalted mysticism and bestial sensuality, are combined. Kokoschka began to study this central theme as early as 1908, when he illustrated *The Dreaming Youths,* a volume of poetry published in Vienna, with a number of lithographs. Its theme was erotic love, and the illustrations show the decisively Byzantine influence of the Jugendstil and of Hodler's 'parallelism'. Sometimes their tone is openly formalised and fairy tale, sometimes strongly naturalistic. Kokoschka's experience before 1907, at the School of Arts and Crafts in Vienna, was, broadly speaking, influenced by naturalism of an Impressionist type (brought up to date with a lyrical style borrowed from Klimt) and by the ornamental linear ideas of the Secessionists (which included the influence of Japanese woodcuts). In Kokoschka, the line is never an end in itself, and within the rhythmical pattern that scarcely ever develops in an unbroken way, there is a tender, startling vein of human feeling, an inventiveness that gives new blood to the exhausted formalism of the Jugendstil. This is very obvious in the later (1909) illustrations for *Murder, Hope of Women,* in which Kokoschka proves he has reached remarkable graphic maturity. The contrast between the fine, nervous lines and the violent, brutal gestures, within a rhythmical, tense and inexhaustibly fertile design, and the figurative inventiveness, all show Kokoschka working at an intensely creative pitch.

By 1907, Kokoschka was already using forms as a means of pure expression, intensely envisaged in a new idea and form of space, and using colour in a new way, too, entirely unlike that of the Secessionists. Between 1907 and 1910 he made a dramatic series of portraits – *Papa Hirsch* in about 1907, *Player in a Trance* in about 1908, *Karl Kraus* in about 1908, *Adolf Loos* in 1909, *Boy with his Hand Raised* in about 1909, *Child with his Parents' Hands* in 1909, *Ludwig von Janikowsky* in 1909, *Constantin Christomanos* in about

The consciousness of visions

Fig. 2, Pl. 1

Figs. 4, 6

Fig. 7

Fig. 8

Fig. 9
Fig. 10

1909, *Peter Altenberg* in 1909, *The Duchess of Rohan-Montesquieu* in 1909–10, *August Forèl* in 1910, *Peter Baum* in 1910, etc. These were all brutally and bewilderingly aggressive, and dominated by an explosive, barely controlled inner sense of tragedy and neurosis, shown particularly in the sitters' hands. These hands are horribly stiff, either clasped spasmodically or unnaturally contracted in a way that has nothing to do with the attractive, aesthetically conscious ideas of Art Nouveau, in Schiele, for instance, and are far less human and emotive of suffering than those of Van Gogh. Indeed, they remind one of some brutal descriptions by Rimbaud *(Les Assis)*, though entirely lacking his fierce sarcasm. The eyes, in these figures, correspond to the hands: they represent the body and the soul: still, staring eyes, exalted, inner-looking, feverish. The character is violated by a strength that alters his appearance, moving within him and demanding psychological answers. Michelangelo Masciotta has noted that Kokoschka often shows 'such harshness that the sitters come out of it diabolically scarred, revealing bitter passions sometimes hidden from themselves . . .' Or else, in painting a portrait, Kokoschka sees beyond the sitter's present appearance, the physical and psychological traits which he will assume when the ravages of time appear more brutally and more significantly in him. Argan has spoken of the 'destructive portrait', 'the portrait as a murderer'; a realisation that the conventional figure dies in order to reveal the life of authentic existence.

Kokoschka's portraits seem to show two violent and contradictory yet equally strong impulses. On the one hand, the subjects are profoundly earthy, and this is shown dramatically and in often ferociously physical ways; sometimes these are actually disgusting, obviously decomposing. On the other hand, as a result of the way Kokoschka's method of working at things slowly matured and moved from vision to visionariness, as it became more introverted and interior, some detail of the figure is made immaterial, so that the people look like ghosts: desolate visions of a ruined soul, with something landscape-like about them.

In 1912 Kokoschka wrote: 'No-one will ever be able wholly to describe the consciousness of visions or to chart their history, because that is life itself . . . The vision appears to us as a sudden state, a first glance, the first cry of a child newly out of its mother's body. The essential character of life is the consciousness of vision; a characteristic both bodily and incorporeal, and perceived according to the direction of the current. Consciousness cannot be completely conceived in visions, for they are moving things, freely evoked, a power conferred that chooses between the forms that flow into it, and can do what it wishes with them. In order to describe the consciousness of visions, I imagine on the one hand a steady point in life, and on the other a tall building that not only goes deep into the waves but rises high into the air. Consciousness is the cause of all things, even of imagination. It is a sea that has visions for its horizon. Consciousness is the grave of things, the place where they cease to exist, beyond which they end. And when they have ended, it seems that they no longer have any essential existence except in the visions in me. They exhale their spirit, as a lit lamp consumes its oil through the wick.'

Pl. 6–7, Fig. 11

The year before (1911), Kokoschka had used religious subjects in some of his paintings *(The Annunciation, Golgotha, The Flight into Egypt)*, which show this rarefied visionary spirit in a special way: a spirit that remained with him even when, under the influence of Rembrandt, he began the intense conversation with himself which appeared in a series of self-

Pls. 11, 30, Figs. 15, 34
Fig. 43

portraits, the first (1913) of which (apart from the one in which he appeared with Alma Mahler, at the end of 1912, in a kind of transparent liquid, as if hypnotised by the presence beside him) shows a face pinched with introspection, stuck on to a poisonous metallic background of cold reflections that seem to come from aluminium, with large, staring, inward-looking eyes. Even in a short time Kokoschka's style developed fast. Although each painting obeys the logic of what has gone before it, the image gradually loses its naturalistic supports and the vision obeys an inner logic, a mysterious

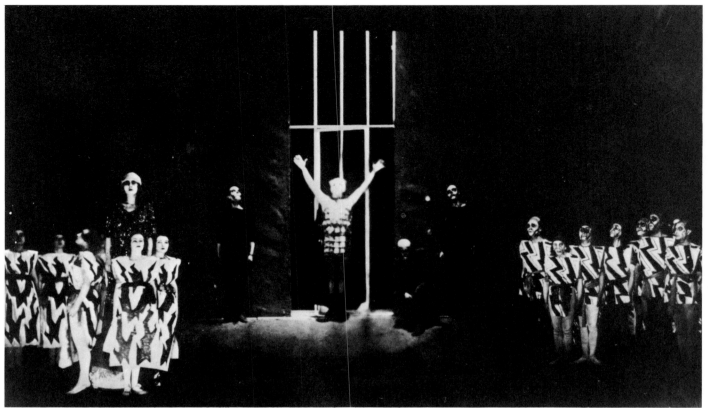

12 Set for *Murder, Hope of Women*
1920,
Frankfurt

13 Study for *Der Gefesselte Kolumbus*
1913, charcoal drawing

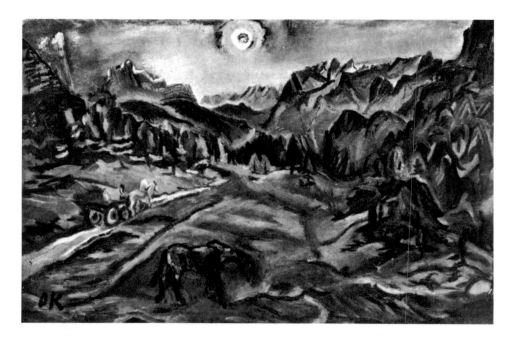

14 *Dolomite Landscape with Three Crosses*
1913, oil on canvas
$32\frac{1}{4} \times 46\frac{3}{4}$ in (82 × 119 cm)
Private collection,
Hamburg

inner call that recalls Van Gogh; this hauntingly seems to identify the emotional intensity of the sitter and that of the painter himself: at this stage, Expressionist existentialism reached a high level. Thick brush-strokes of pure flat colour, and hints of other forms painted over them derived from the late Impressionists, alternate with agitated lines on uneven patches where the paint is thin and only just covers the canvas in dull muddy tones that are strongly allusive and symbolic. This technique is sublimated in many watercolours, which are indeed governed by the violent contrast between the strongly marked line and the pale, watery paint. The subjects (or the single figurative steps in a single painting) seem to be set firmly in an objectivity that has no way out, as if Kokoschka was isolating each word of what he was saying, giving it a strength of its own that had no communication with anything else, and using a technique he also employed in his plays.

The Tempest

Pl. 2

Fig. 3

Fig. 13

In 1910 Kokoschka began to contribute to the review *Der Sturm,* in which many of his portraits appeared. Meantime his landscapes *(Hungarian Landscape* in 1908, *Dent du Midi* in 1909–10) were becoming more relaxed and sometimes even fanciful. Stylistically, he anticipated the style of his maturity in an interesting way, using an outdoor technique that recalls Turner, though with explosive breaks in the line. His still-life painting, on the other hand, *(Still-life with Pineapple* in about 1907, *Still-life with Sheepskin and Hyacinths* in 1909) seem impatient with the earthly, flesh-and-blood components of the image, which is given a heavy, dense, visionary colour, a stifled air that is a long way from the visionariness of the Expressionists' use of colour and recalls, if anything, the exhausted psychic transparency of Odilon Redon. In the illustrations for *Murder, Hope of Women,* in the drawings for Albert Ehrenstein's *Tubutsch* in 1912, in the series of lithographs for *The Fettered Columbus* in 1913 (where Kokoschka dealt with the old theme of sexual slavery once again) and in his activity as a dramatist *(Sphinx and Strawman, The Burning Bush)* he reached the zenith of tension and despair in dealing with the theme of the relationship between the sexes, with implaccable masochism. Munch had already dealt with the theme, and Kokoschka now showed woman (whom he considered immortal, so that the only true rebel was the murderer) as tyrannically dominant. He also depicted the sexual misery of a man who was psychologically overwhelmed by a woman. The sun, inexorably destined to set, represents the man, while the cold moon is the symbol of woman, who, when she comes to look like the moon, also becomes a wild beast: in fact, Kokoschka's female figures are furious, implaccable idols, cruel, obsessed

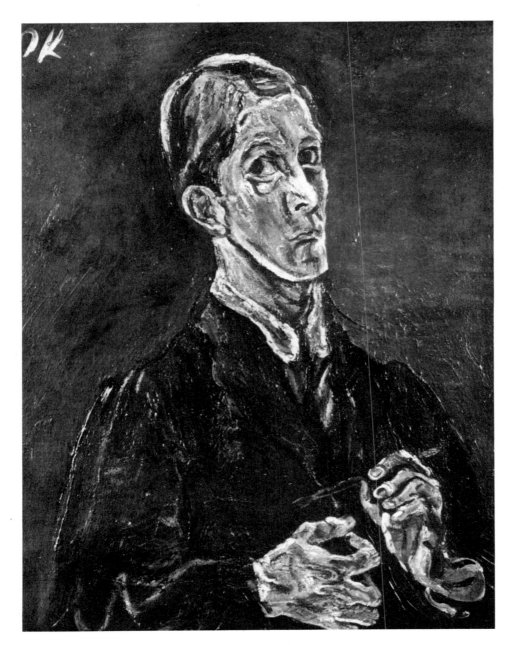

15 *Self-portrait with a Brush*
1914, oil on canvas
$31\frac{1}{2} \times 25\frac{1}{4}$ in (80 × 64 cm)
Private collection,
New York

furies. The moon often appears in Expressionist paintings. It is of course
a deceptive, sinister moon that brings misfortune and apocalypse, shining
over desolate, misty landscapes; its appearance suggests ecstasy or perhaps
stillness, as it watches the embraces of lovers indifferent to everything but
themselves.

Kokoschka's relationship with Alma Mahler was a decisive factor in the
way his work developed up to 1915. The image dissolved into the back-
ground, tending to blur the distinction between the two, increasing the
imaginative dimension of space and actually involving the figure more and
more in its surroundings. Inevitably the spectator is similarly involved,
and this means that the image shows some elements that are typically
Baroque. Dull, acid tones dominate the colour, and sinister gleams glow
from the interior of the painting. Significant works of this kind are *The
Couple* (1912), *Still-life with Putto and Rabbit* (1914), *Dolomite Landscape
with Three Crosses* (1913), and, in particular, *The Tempest* (1914), a highly
autobiographical and symbolic painting, in which the fact that Kokoschka
was painting about himself in no way detracts from the extraordinarily
strong sense of revelation and visual inventiveness; in fact, it enhances it.
A pair of lovers, oblivious beneath the moon, lie lulled by the motion of a
boat floating into the infinite. It is well known that this painting referred
quite definitely to Kokoschka's relationship with Alma Mahler, but, as he
himself said, it was painted when the relationship was entirely over. The

Figs. 42, 16, 14
Pl. 8–9

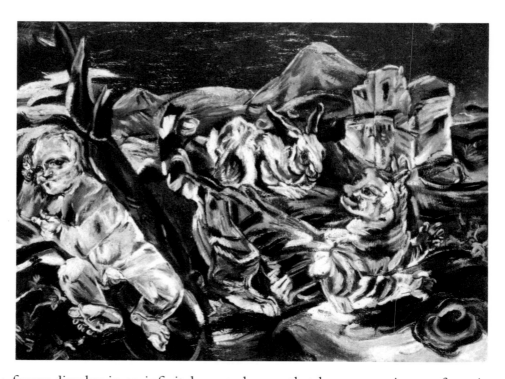

forms dissolve in an infinitely unreal space that becomes a sinuous form in itself, agitated and overflowing as it is in the Baroque. Symbolic, literary and autobiographical meanings are clear in another picture painted in 1915: *The Knight Errant*. It is a self-portrait in armour: the knight is lying in an apocalyptic landscape full of sinister, nightmarish forebodings. Kokoshka was probably alluding to his imminent departure for the front, to the definite end of his relationship with Alma Mahler, and to the fact that he was destined to be a wanderer.

Fig. 17

The Dresden period

Kokoschka was called up just when the first great period of his work was coming to an end, and another stage in it was coming to maturity. This second stage, which lasted from 1917 to 1924, is known as the Dresden period; in it Kokoschka was less visionary, his symbolism was weaker, and he dwelt with surprise and anxiety on the human condition and on history. He meditated on the masters of the past: Tintoretto, Rembrandt, Altdorfer, Cranach, Brueghel, the Austrian Baroque of Maulpertsch. Some of the constant elements of Expressionism appear indirectly in his paintings of the period: the theme of persecution and the diaspora (*The Emigrants* of 1916–17), the longing for a deep, true brotherhood among men (*The Friends* of 1916–17), the myth of 'naked man', the relationship between man and woman (*Orpheus and Eurydice* of 1917, *The Pagans* of 1918–19). The forms seem slack and unfinished, on the point of melting away, overwhelmed by their own rhythm. The brushwork is mobile, abbreviated, sometimes with an angry, convulsive rhythm (*Lady with Parrot*), sometimes held up by broad *taches* of an almost abstract kind (*Summer I* of 1922, *Two Girls* of 1921, *Woman in Blue* of 1919) or cut by sharp, almost slashing marks, as in some landscapes of Berlin, Vienna or Dresden, or in portraits like that of Nancy Cunard, from 1924. The colour is intense and deep, and Kokoschka's own participation is heartfelt and very human.

Pl. 12–13

Fig. 18
Figs. 19, 20

Fig. 22

Pl. 16
Pl. 18–19

The form dissolving in the space around it, and the close fusion of drawing and colour (so great that in many sketches it seems as if Kokoschka was drawing in colour) suggest that he was evolving towards rather impressionistic ideas. This is clear in a series of landscapes made while he was travelling and working intensely in Italy, France, England, Spain and North Africa: *Venice, Boats at the Dogana* (1924), *Paris, the Opéra* (1924), *The Theatre in Bordeaux* (1925), *Marseille, the Port, I* (1925), *Monte Carlo* (1925), *Amsterdam, the Amstel* (1925), *Tower Bridge, London* (1925), *Richmond Terrace* (1926) and many others. Nature seems to have given up its usual

, Fig. 24
Fig. 25
Figs. 26, 27

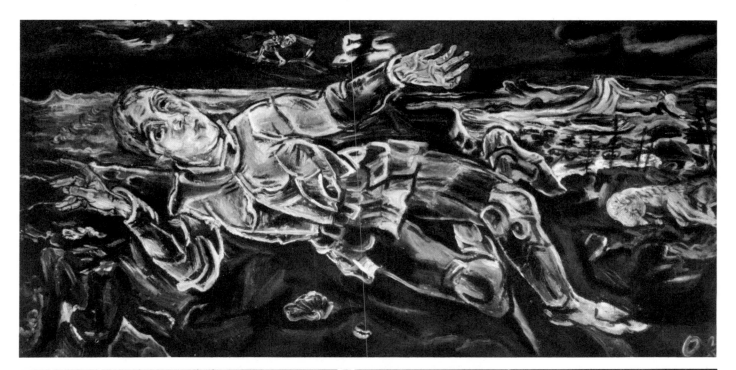

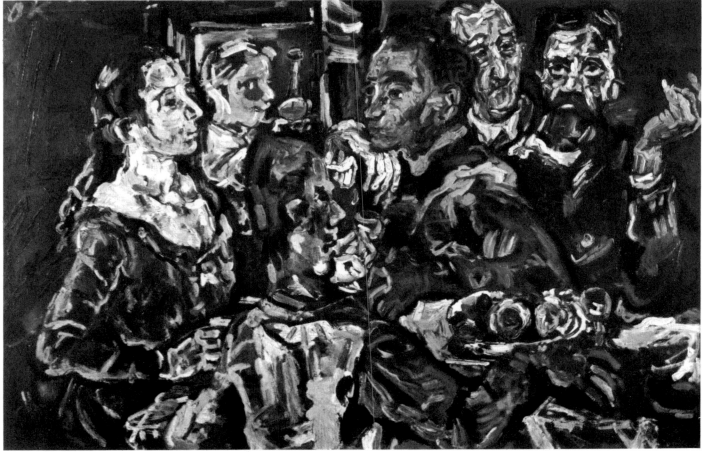

17 *The Knight Errant*
1915, oil on canvas
35½ × 70¾ in (90 × 180 cm)
Unknown collection

18 *The Friends*
1917–18, oil on canvas
39¼ × 59 in (100 × 150 cm)
Neue Galerie der Stadt Linz,
Linz

19 *Orpheus and Eurydice*
1917, oil on canvas
$27\frac{1}{2} \times 19\frac{3}{4}$ in (70 × 50 cm)
Unknown collection

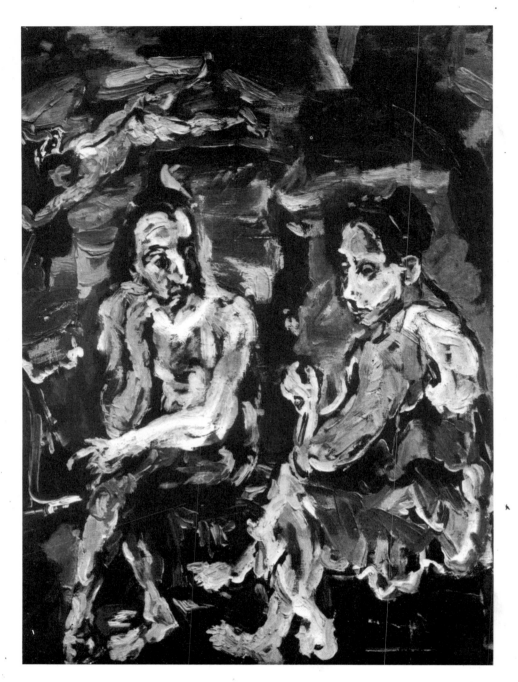

Figs. 29, 30, Pl. 23

Fig. 31

menacing and dark appearance, and to allow itself to be investigated almost calmly, sometimes even with flowing and easy unmysterious, calligraphic-looking lines. These paintings sometimes show the enthusiasm of discovery (which was not, of course, that of a mere admirer of scenery but of a man of European culture), and the joy of seeing particular visions, but what is still authentically Kokoschka's own is the composition itself—the way earth and sky are balanced, the arrangement of the angle of vision, the way space spreads or contracts, and the richly asymmetrical view of things that may, perhaps, have been a result of his congenital astigmatism. The disquieting aspects of reality reappear almost unexpectedly in the animals, which take one back to a nature that is less domestic, and essentially mysterious: *The Cat* (1926–27), *Giant Tortoises* (1927), *Mandrill* (1926), *Roebucks* (1926). Portraits of animals are another recurrent theme in German painting: Franz Marc used a kind of panic vision of the world by fusing animals with landscape, while Kokoschka irreverently linked man and animals by making real portraits of animals whose sinister, magical humanisation seemed to put across all kinds of ambiguous messages. It is, indeed, in his work with animals that Kokoschka examines the problems of metaphor and allegory. Landscape, above all some excited sketches from his time in Prague, such as the *View from the Villa Kramář*, of 1934–35, or the *View from the Schönborn*

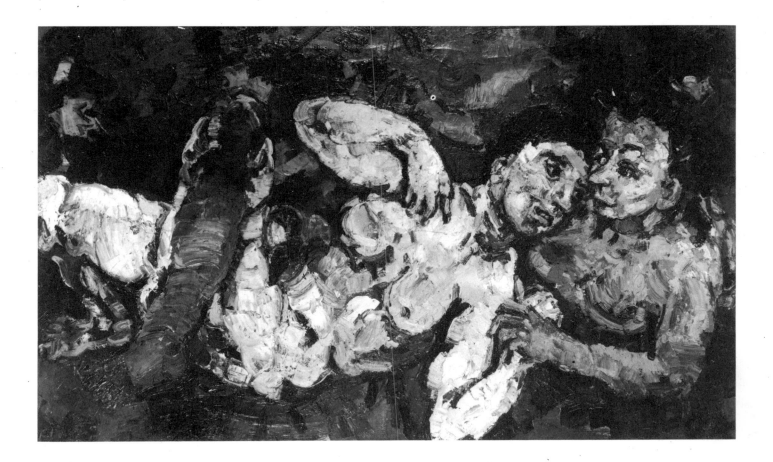

20 *The Pagans*
1918–19, oil on canvas
$29\frac{1}{2} \times 49\frac{1}{4}$ in (75 × 125 cm)
Wallraf-Richartz-Museum,
Cologne

21 Eleven bars of Schönberg's
Pierrot Lunaire

22 *Two Girls*
c. 1921, oil on canvas
46 × 31½ in (117 × 80 cm)
Private collection,
New York

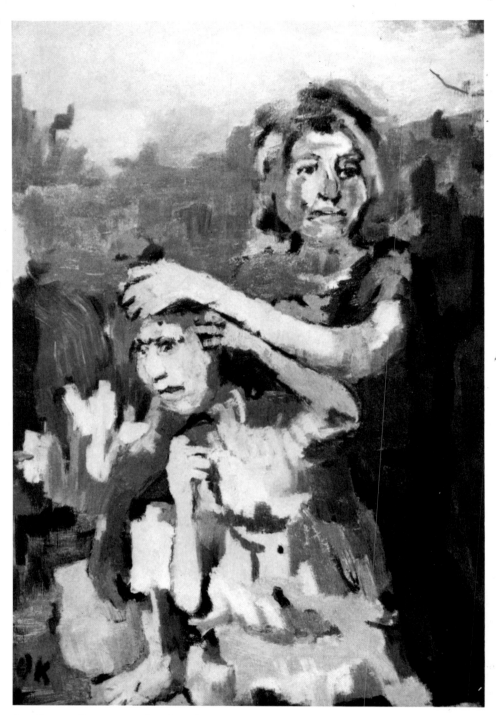

Gardens, of 1935, and other later works from his English period, brought to maturity the style that was to remain constant in his landscapes and had already been precisely formulated in drawings: the fragmented vision, with a broken, powdery movement.

The poetry of fragmentation

Mittner, referring in particular to its literary side, considers Expressionism as a 'poetry of fragmentation'. The fragmentation has two main characteristics: either it is empty or it is full, 'too full, absurdly full'. Kokoschka is one of the 'full' Expressionists. His is the agitated vision of a man who sees a great many things, even negligible details in a single field of vision, dancing before his eyes and enriching his power of perception: all these things move from a visual to a visionary and imaginative plane (understood as violent introspection as well), going beyond the sensible world to a kind of intuitive vision that discovers unknown movements, lines and meanings, suspended in an atmosphere that is silent yet full of shouting. This obsessive fragmentation is in fact the original way Kokoschka proposed to deal with the Expressionist dualism of shouting as opposed to geometry, surprise as

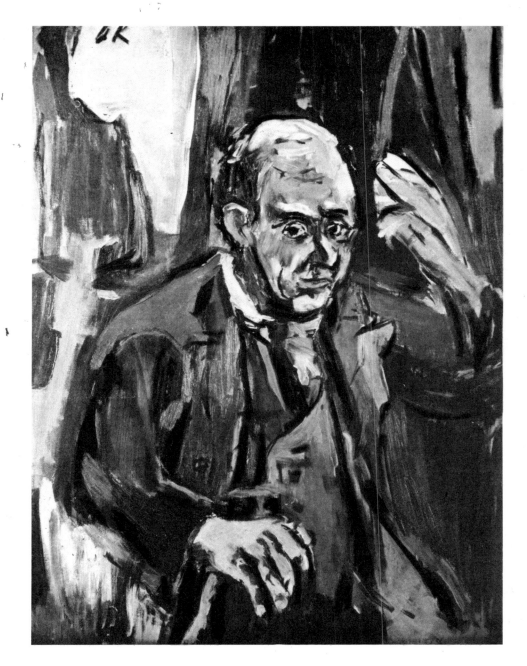

23 *Arnold Schönberg*
1924, oil on canvas
$37\frac{3}{4} \times 29$ in (96×74 cm)
Private collection,
New York,

opposed to vision. In him, the shout becomes a murmur, a dull rumble
sometimes a controlled scream: while geometrical abstraction is lost in a
vital energy that possesses the world through analysis, according to methods
like Husserl's phenomenological reduction. The way in which Kokoschka
reduces colour to lines corresponds to Kandinsky's way of fusing the drawn
form with the coloured form; only that, instead of the febrile excitement
of Kokoschka's paintings, Kandinsky's show a strict control of feeling.

Kokoschka's contact with the world is visual and at the same time an
anguished cry; but his dawn-like vision is broken at once by a tense parti-
cipation in things, which tends to find their appearance important when
least accepting them and fixing them in the context of the image. This
results in the classic Expressionist condition; found also in the drama and
in lyrics—a state of shock and tension. Kokoschka's surfaces are in fact made
up of rents, tears, convulsive movements that suggest aggression or disin-
tegration through continuous or broken lines. These lines are never super-
fluous or unmotivated, and they all act together to make up the organic
structure of the image. The impression is one of instability, of a precarious
limbo strung between shouting and silence, between catastrophe and life:
the secret geometry of the world, its sunken primordial form. When the
image is composed it pays tribute to uncivilised art: Kokoschka's man (like
that of Kirchner and Heckel) combines the suffering mobility of his own

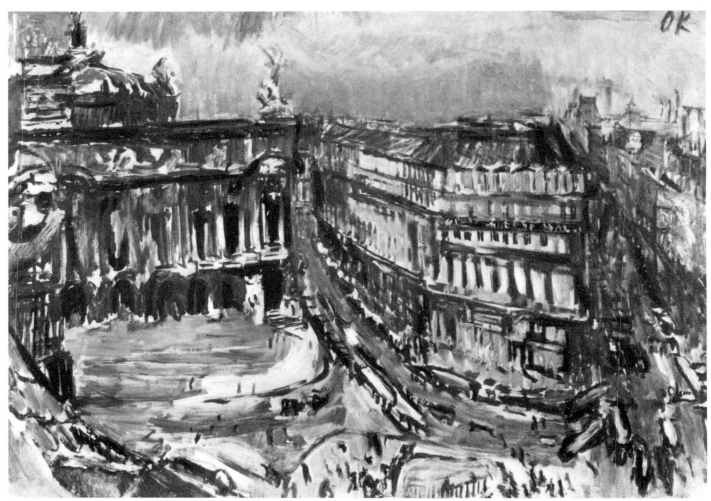

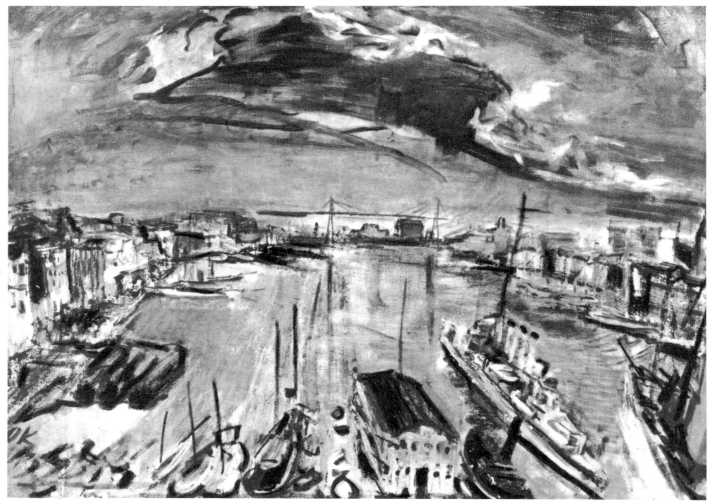

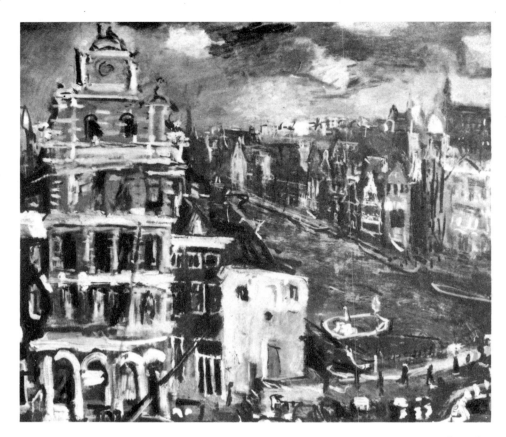

24 *Paris, the Opéra*
1924, oil on canvas
$29\frac{1}{2} \times 45\frac{1}{4}$ in (75 × 115 cm)
Private collection,
New York

25 *Marseille, the Port, I*
1925, oil on canvas
$28\frac{3}{4} \times 39\frac{1}{4}$ in (73 × 100 cm)
Private collection,
Basle

26 *Amsterdam, the Amstel*
1925, oil on canvas
$26\frac{1}{4} \times 29$ in (67 × 74 cm)
Private collection,
Cologne

Gothic features with the animal anthropomorphism of African idols. This shows Kokoschka's revolt against the classical type of beauty and dull bourgeois respectability; it even shows him undermining the symmetrical Platonistic idea of the structure of human anatomy.

One point that should be emphasised is the function Kokoschka gives to form, using the word to mean the physical expression of style. That his style is strongly conscious of its function is quite clear: as the Expressionists believed, what matters is to give the world the purifying message of man in revolt; to transmit and communicate, if necessary, the revolt itself, as drama in action beyond and above all stylistic conventions or problems of form. This means, as we have said before, that art is not considered as something which seeks but as something which expresses, that is, an art which does not overcome problems of form so much as ignore them, using them only as a new means of communication. As the most coherent and immediate way of passing on a message through the image is to use the conventional stylistic methods, which consist in copying the sensible appearance of things, the Expressionists do, admittedly, communicate through figurative art, but use figures in a way that means their message or organisation must be read in a completely new way. Now, as abstract art seeks for purer forms in order to find a new aesthetic, it follows that Expressionists undervalue or reject the abstract. Kokoschka in fact always categorically rejected the non-figurative, even on the theoretical level, just because it was not contaminated enough, not involved enough, above all not compromised with the world; indeed, he maintained that separation from the world, as a result of the process of abstraction, led to the dehumanisation which is the cause of the present break-up of society and man's alienating slavery to science and technology, extending to everything from politics to economics.

This may have been a general limitation of Expressionism (and one that was quite understandable, considering the context in which it existed), but in Kokoschka's case it is even more marked if one considers that he outlived Expressionism and its ideas by a long time. Indeed, his repeated tirades against abstract painting make one wonder whether he may not have been, unconsciously of course, consoling himself for having missed the chance of facing up to the problems of the non-figurative; whether, indeed,

having missed the right moment of history, he was not making a virtue of necessity, particularly as he does not attack the abstract merely by making a distinction between what is art and what is not art, but denies the whole artistic and cultural validity of the avant-garde, condemning methods and techniques by using standards that would condemn his own work, if they were used against him.

The rediscovery of Classicism

Kokoschka's later work, in our own time, throws no more light on him than does the work of his maturity. The process of breaking up the line, found in his sketches in the thirties, was developed further. The whole image is composed of groups of lines and strokes, sometimes thick, sometimes thin, sometimes widening out abruptly into splashes of colour, agitated lines which are never flowing and express the authentic energy formed by the image. The colour becomes noticeably lighter. Kokoschka seems to have acquired a Mediterranean sunniness, which, in various ways, he transfers to other latitudes. Definitely sunny is *London, the Houses of Parliament* (1967), steeped in a cruder light is *Berlin, August 13* (1966), and vibrant with metallic reflections is the spiky view from the air of *Manhattan with the Empire State Building* (1966).

Fig. 41

Fig. 40

During the sixties, Kokoschka made a series of watercolours of flowers, alternating with others of animals. Finding real freedom in his translation of the subject, he managed to be extremely exact; indeed, his flowers might have been drawn for a modern textbook.

The most important event in the latter part of Kokoschka's life as an artist is his rediscovery of the Classical. Both his style and his ethical message are less tensely put across, the northern fogs seem to have lifted, and he appears to have reached the end of his desperate, breathless search for the human dimension by discovering the world of Greece and of Homer's Mediterranean, the history of Israel, Aristophanes and Shakespeare. In

27 Richmond Terrace
1926, oil on canvas
$35\frac{1}{2} \times 51\frac{1}{4}$ in (90 × 130 cm)
Private collection,
Basle

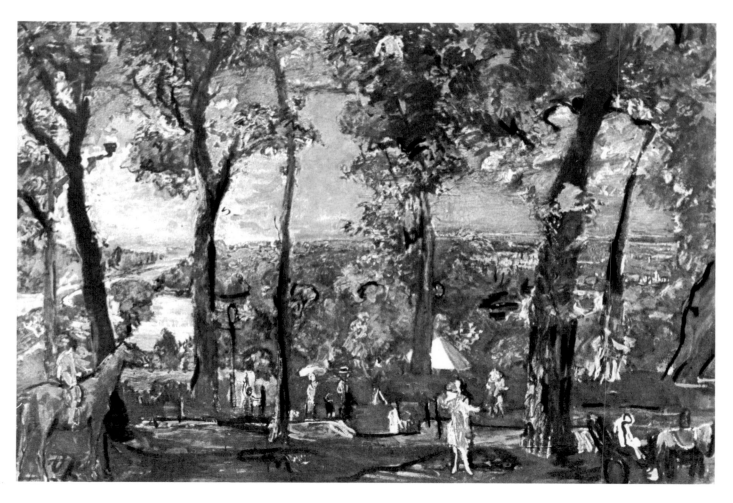

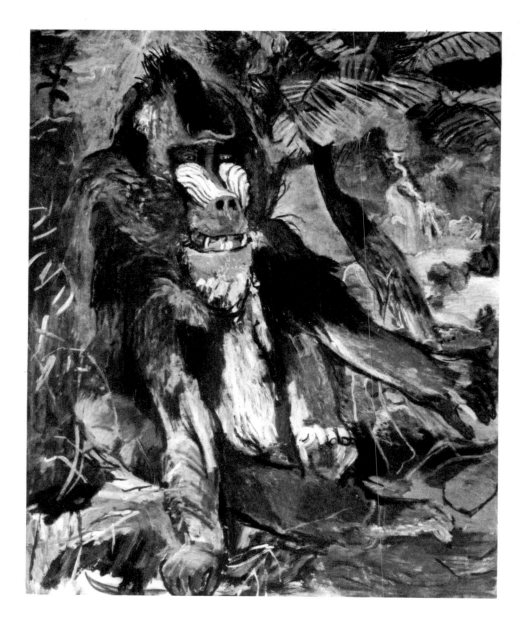

28 *Mandrill*
1926, oil on canvas
50 × 39¾ in (127 × 101 cm)
Boymans van Beuningen Museum,
Rotterdam

1954 he painted the well-known triptych of *Thermopylae* for the students'
house at Hamburg University; in which he did not keep to mythological
figures but gave the story a contemporary setting. Indeed, he managed to
do what the Expressionists had done, although, when they went back to
the Gothic tradition of Dürer and Grünewald, they never managed to
realise it successfully: that is, he managed to create, in works of art, a
reality and a space that did not exist before the work of art was made but
came into being as he painted them. The broad setting does not mean a
lack of careful episodic detail: indeed, the fullness of the context gives it a
force and concentration. Bright sunshine, which in the third panel (the
battle) becomes dazzling, blurs the outlines, but this does not mean any
diminution of effect: on the contrary, it concentrates on the narrative
details and allows the figures to be crowded together within the structure
of the image.

From 1961 to 1963 he illustrated *King Lear*, celebrated Greece and made a
series of lithographs on his impressions of a visit to Apulia, which he con-
siders a Homeric Eden: 'To me, this, not Constantinople, is the gateway
to antiquity', he told Wolfgang Fischer. After designing the scenery for
Verdi's *Un ballo in maschera* in 1967 he illustrated *The Frogs* by Aristophanes
in 1968; then, like Rembrandt, turned to the Bible as if it were something
still alive, and was struck by the drama of Saul and David. To this he
dedicated an album of drawings, through which he told the whole story
of the two characters, from the flight of the asses of Kish, which Saul

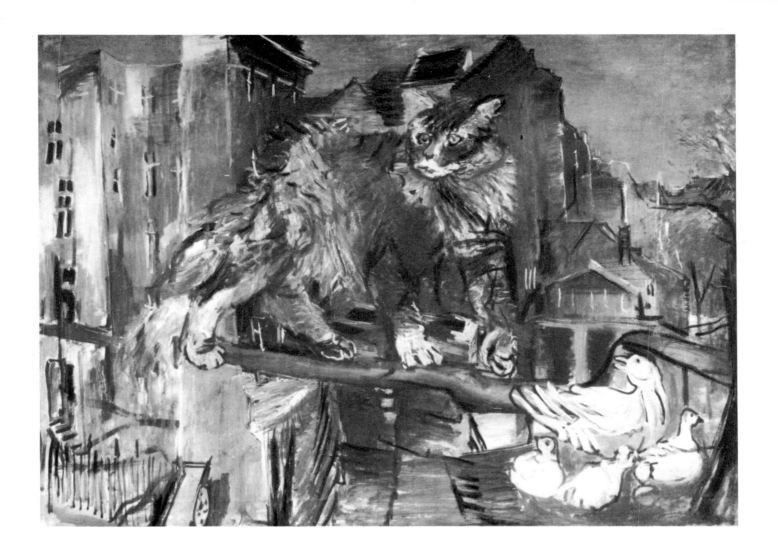

leaves in order to go and seek a kingdom, until the death of David. Once again, a reason for Expressionist dialectic. Saul is the mysterious character which the dark, transcendent forces of nature use for ends that will betray him: this means despair. David, on the other hand, is touched by celestial grace; he is a favourite of the people and loved by Jonathan and Michal, children of the choleric Saul; he can forge his own destiny, project himself beyond the limitations of life.

Kokoschka took a dramatic part in this story. He was not making a historical reconstruction or paying homage to the past; rather, he was experiencing it in action, it was a way of showing man the great dramatic themes of the whole of humanity, which included the drama of time: Saul irrevocably old and angry with his eighty years, David young and master of his destiny. Picasso seeks to restore his own old age by celebrating Susannah bathing, in an Arcadian-like erotic scene that suggests the *voyeur*; Kokoschka still tries to bend reality, making the embers of Expressionism glow again by showing the inner struggle of the human creature threatened by death.

He uses his stories with inexhaustible energy in the drawing: his figures have lost all thickness, and are reduced to the dramatic essential of the skeleton, worn down by the struggle between light and darkness. Their forms are conditioned by Kokoschka's impassioned investigation of human life, and by a vitality that is always emotionally full, and that burningly combines imaginative intuition and technical skill: this is, in a poetic sense, Expressionism.

Kokoschka is now over eighty and still at work. On his still unfinished work, *Herodotus,* he might write what Goya wrote when he was over eighty under the picture of an old wandering Titan: 'aún aprendiendo' (still learning).

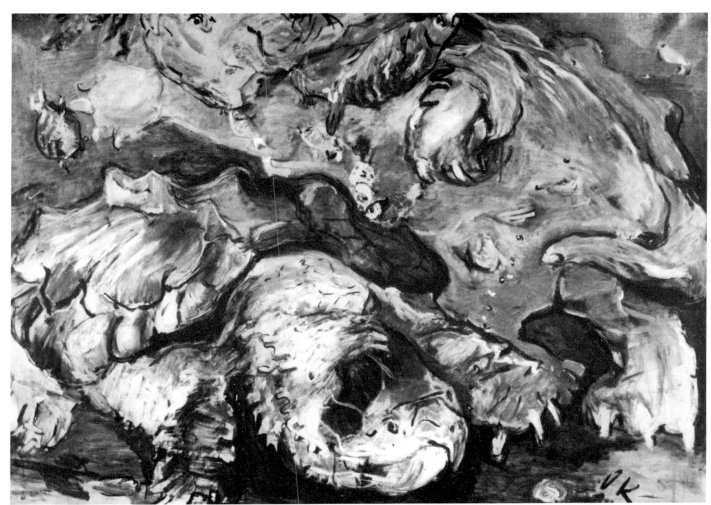

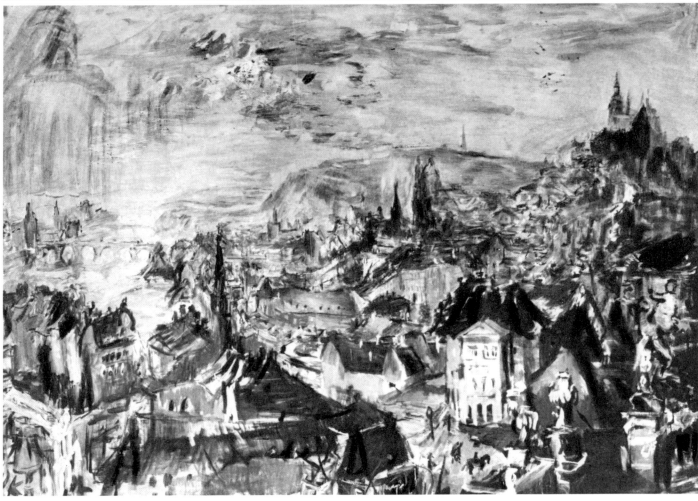

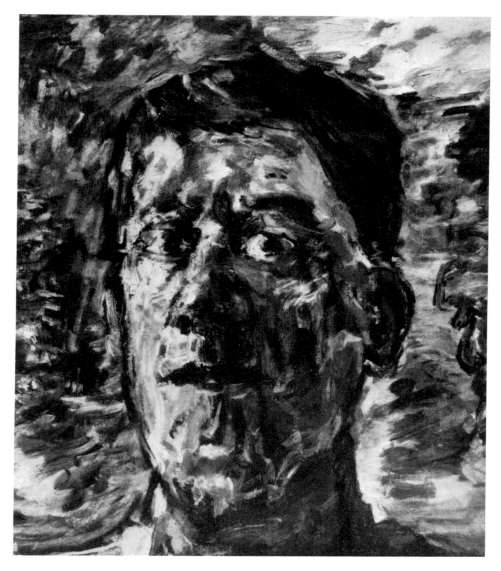

32 *Thomas G. Masaryk*
1936, oil on canvas
$35\frac{1}{2} \times 50\frac{1}{4}$ in (90 × 128 cm)
Private collection,
New York

33 *Summer, II*
1938–40, oil on canvas
$26\frac{1}{4} \times 34\frac{1}{2}$ in (67 × 88 cm)
National Gallery of Scotland,
Edinburgh

34 *Self-portrait*
of a 'Degenerate Artist'
1937, oil on canvas
$43\frac{1}{4} \times 33\frac{1}{2}$ in (110 × 85 cm)
Private collection,
Fort William

Thoughts on non-objective art by Oskar Kokoschka

Today, thanks to hysterical activity in the arts and to the way in which art is formally taught, especially in the United States, we have reached a point where few exhibitions show us the miracle of the sensible world, seen through a pair of open eyes. Society is not at all surprised to find that man and all objects are banned from painting, by the propagandists of art. The robot of the future may be able to eliminate the physical presence of the abstract artist altogether. Why should a machine not put dark lines and splodges and daubs of colour on canvas without the help of man?—daubs in which the avant-garde of the anti-humanistic movement thinks it has found all the secrets of our time . . . Until it is realised that the conflict must not be seen as one between the art of the past and modern art, but as the more essential conflict that has always existed between creative art and non-art, abstract art will be used as a substitute, although society admits that it fails to understand it.

The question we should ask is: has figurative art any real meaning today? Above all when the artist's calling has been entirely misunderstood and most young painters and sculptors today start by painting abstracts. This abstract reality is useful to the scientist as a model for thought. It is a hypothesis that gives a logical explanation, linked in time, to certain phenomena, and this explanation is valid until new realities demand new theories. The recent ideas of physics (light as mass, relativity of time and space), the latest discoveries and technological advances (the splitting of the atom,

35 *Cardinal Elia Dalla Costa*
1948, oil on canvas
$38\frac{1}{4} \times 28$ in (97 × 71 cm)
Phillips Memorial Gallery,
Washington

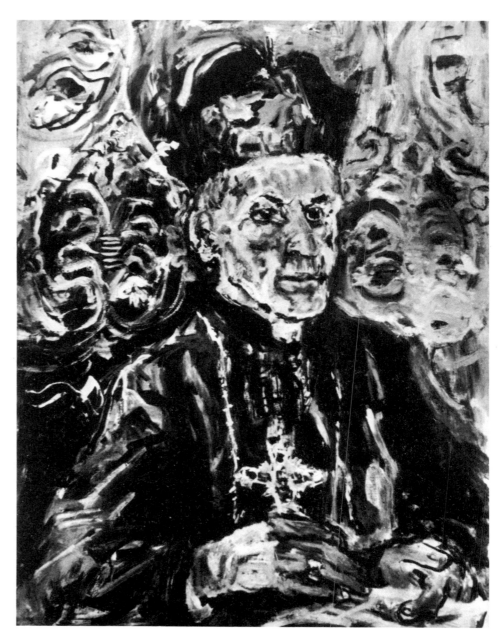

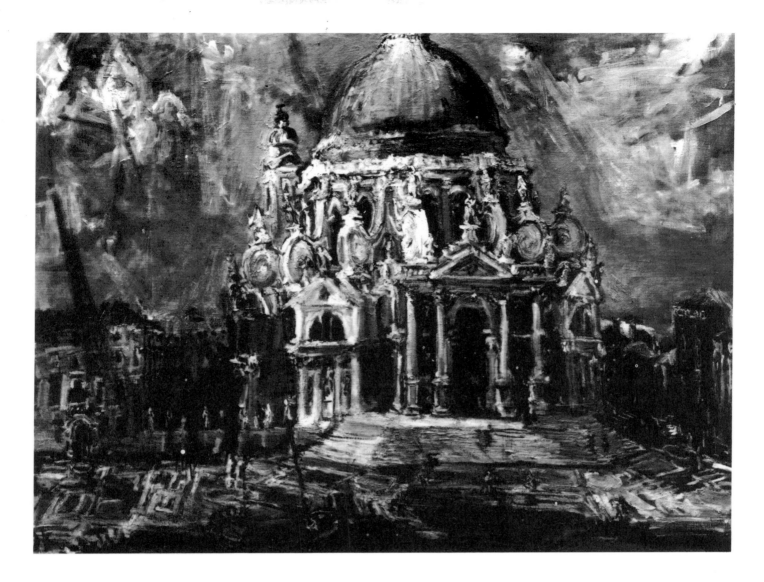

supersonic flight, the new dynamics), as well as the way wars have devastated whole continents, the increase in population, and the intensive pollution of the entire earth, have all brought enormous changes to the world around us. The scientist's mind, which is tied to time, is not in a position to calculate the consequences of all this, which means that the non-scientist is tempted to abandon all attempts to represent his concept of the world. Non-objective art might therefore be our age's protest against a reality that threatens to replace man by the machine and that mass-produces man himself, if we have rightly understood certain recent politicians, who put human and mechanical activity on the same level and judge them in the same way.

For a few artistic snobs, non-objective art reflects a world outside the reality they are fleeing. Their romantic escapism finds a parallel only in the last century, when aesthetes found their nerves unable to bear the increasing ugliness of the businessmen's life, the injustice of imperialistic wars, the way in which people and property were exploited and slave-labour was used. Ethnology, however, has shown us that men have never, in any place, reached an organic social civilisation without figurative art, which leads them to a universal knowledge of humanity and develops their social organisation. Figurative art is a language which communicates knowledge more directly than speech can do, through visible, palpable signs. It is born from the vision of creative man. It becomes the message of a people and life common to the whole earth, beyond time and space, whereas the spoken languages become dead languages and peoples and races disappear. In the best of all possible worlds, as a cynic has remarked, man remains the measure of all things. The only thing that has never changed throughout the process of evolution continues today: the human ability to keep widening and

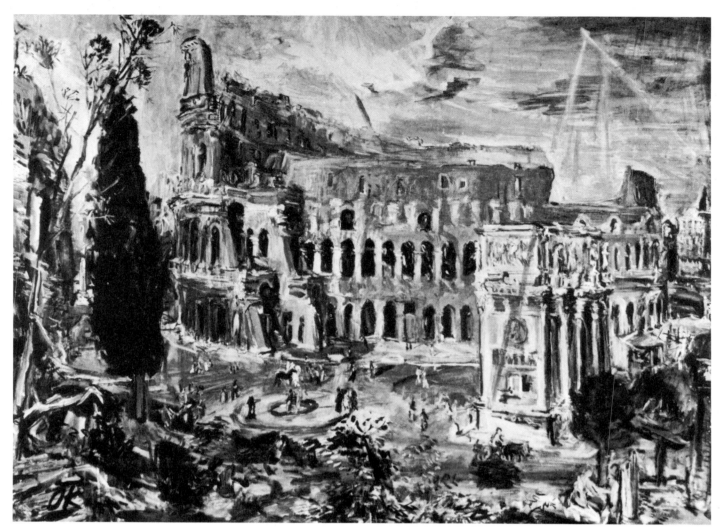

37 *Rome, Colosseum*
1949, oil on canvas
$31\frac{1}{2} \times 43\frac{1}{4}$ in (80 × 110 cm)
Private collection,
Rome/London

38 *Cupid and Psyche*
1955, tempera on canvas
$105\frac{3}{4} \times 103\frac{3}{4}$ in (238 × 233 cm)
Private collection,
Villeneuve

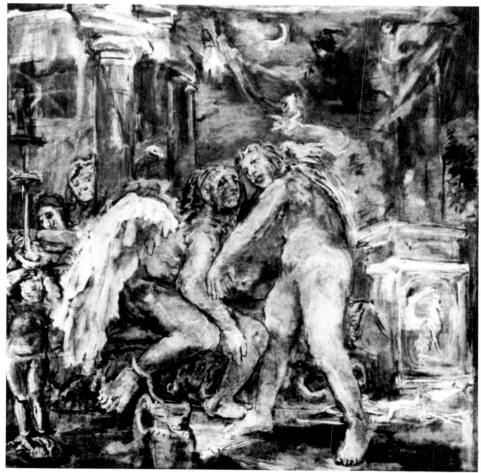

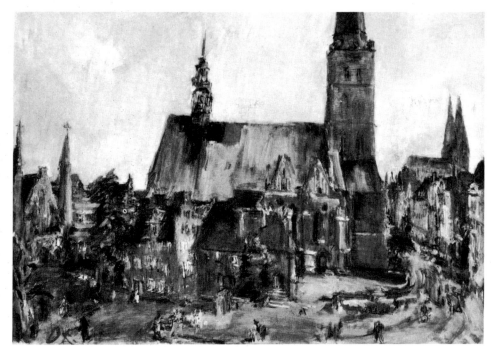

39 *The Church of St James at Lübeck*
1958, oil on canvas
$31\frac{1}{2} \times 39\frac{1}{4}$ in (80 × 100 cm)
Behnhaus,
Lübeck

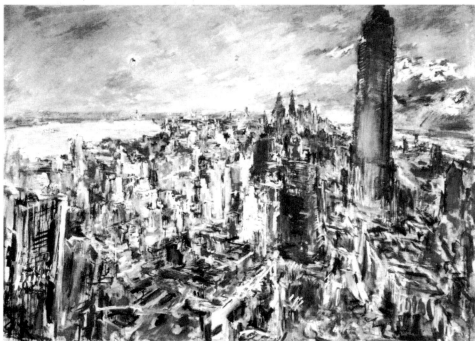

40 *Manhattan with the Empire State Building*
1966, oil on canvas
$40\frac{1}{4} \times 54$ in (102 × 137 cm)
Private collection,
New York

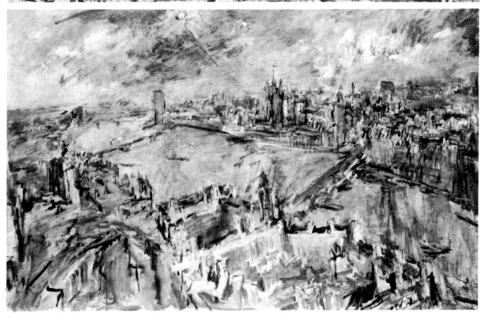

41 *London, the Houses of Parliament*
1967, oil on canvas
$35\frac{3}{4} \times 53\frac{1}{2}$ in (91.5 × 136.5 cm)
Marlborough Gallery,
London

deepening what is human. The creative artist's task is to keep alive the profound sense of human activity, the sense of form, even if a defeatist outlook prevails and makes it a matter of chance whether the human world continues to exist or becomes a chaos of non-objectivity, an empty desert. The dilettantes, who grow more and more numerous, maintain that the abstract world projects the artist's inner life outside him, an inner life in which no-one (particularly future generations) can seriously be interested. In this mistaken activity, the living language of figurative art becomes a dead language, and today's 'abstract' art has to be translated and paraphrased into the written and spoken language, given subtitles to explain what it is saying. It is like dealing with a tribe of savages to whom an art critic has to explain the meaning of the drawings in caves and on rocks . . .

Oskar Kokoschka (1954)

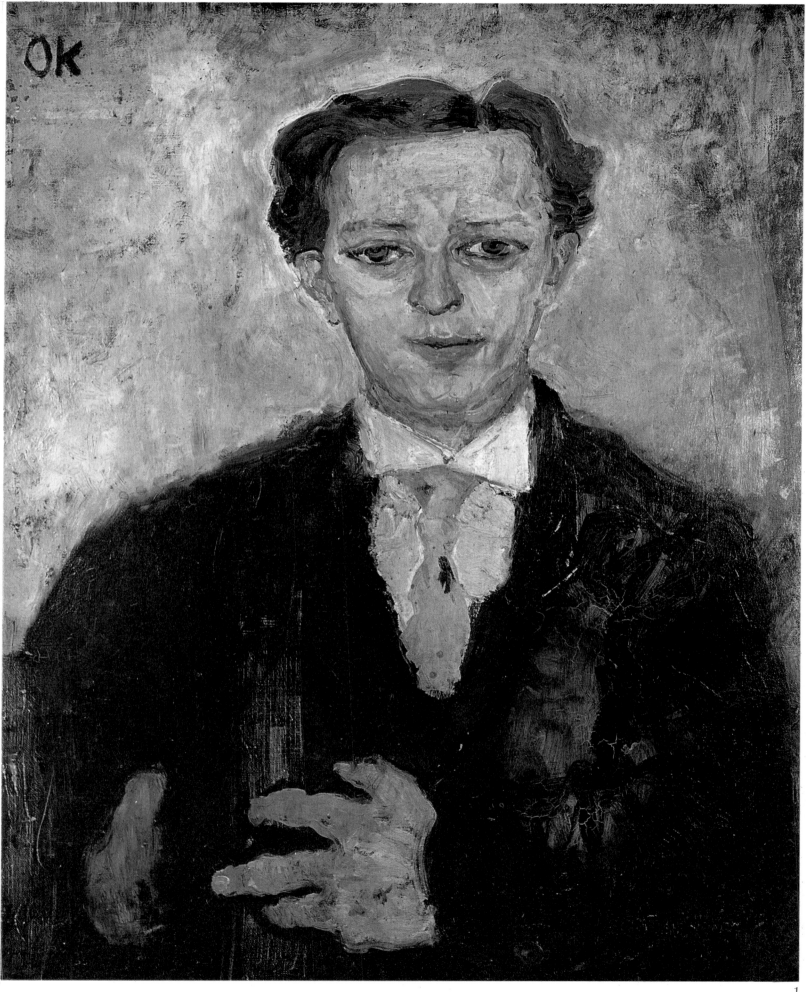

1

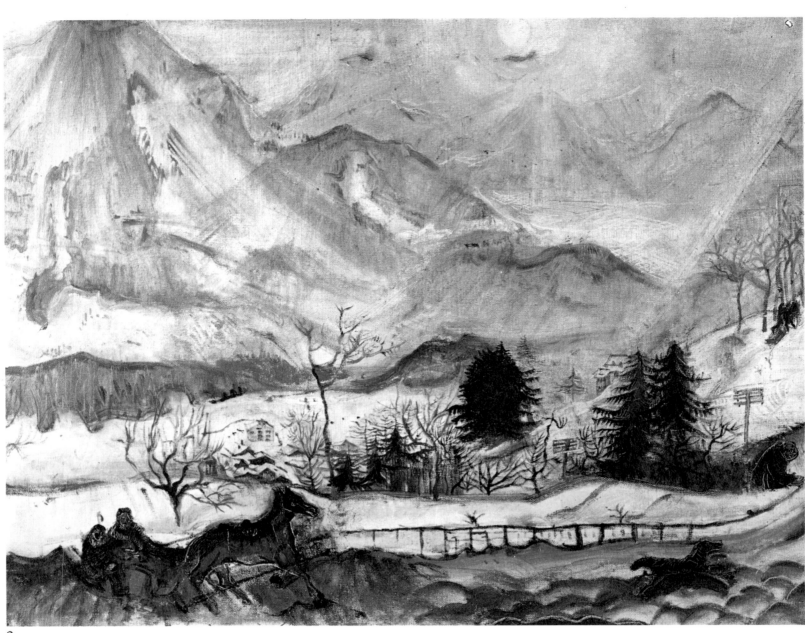

2

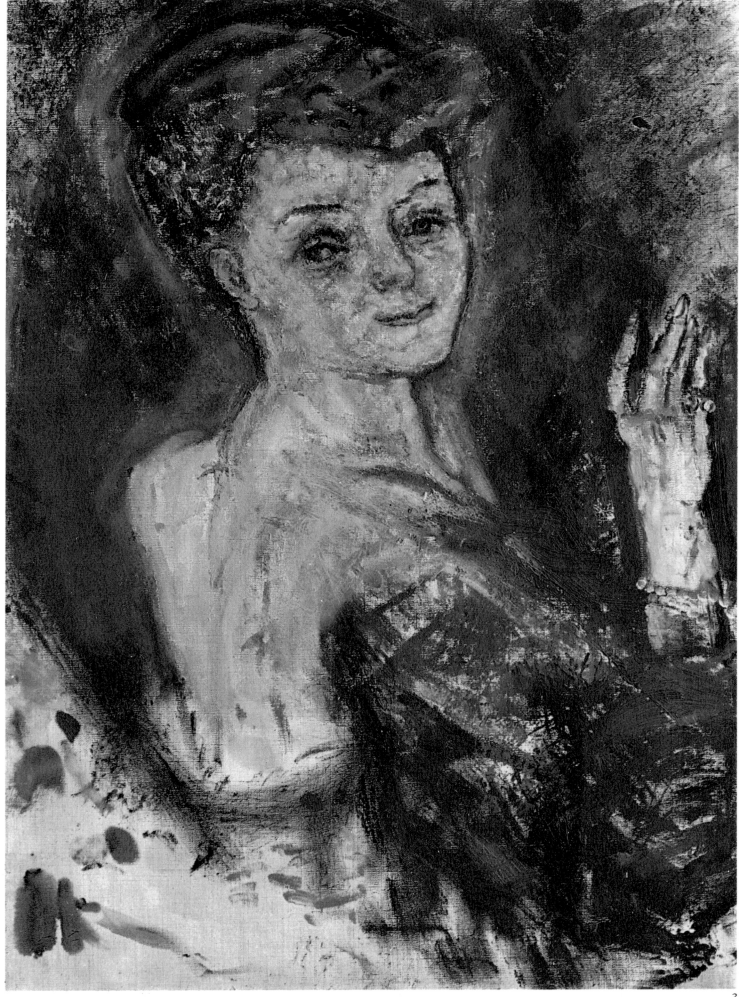

3

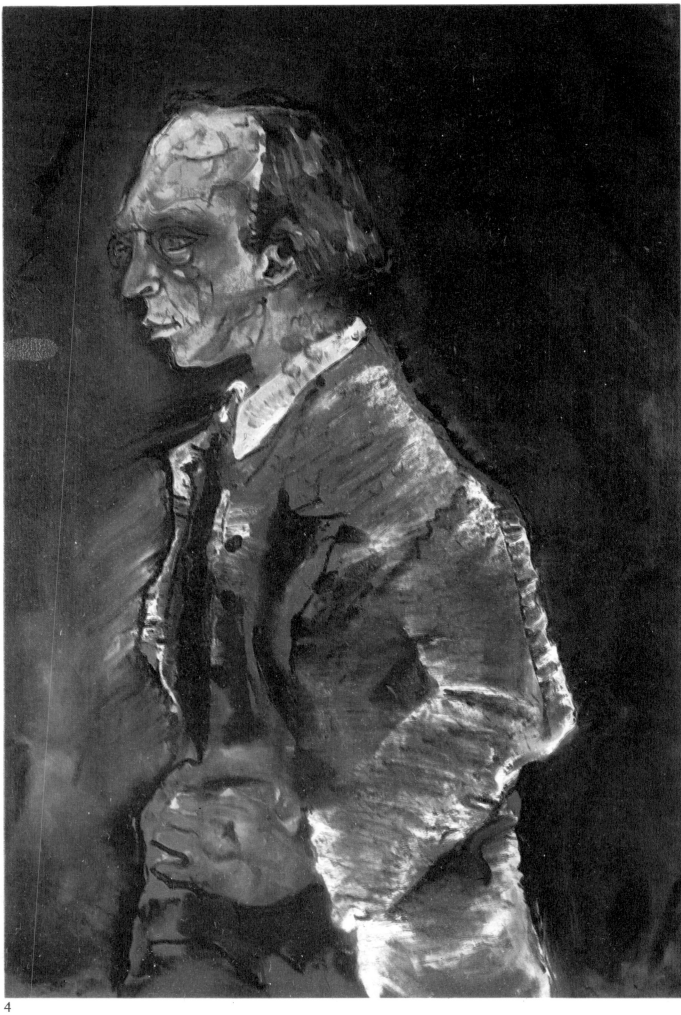

4

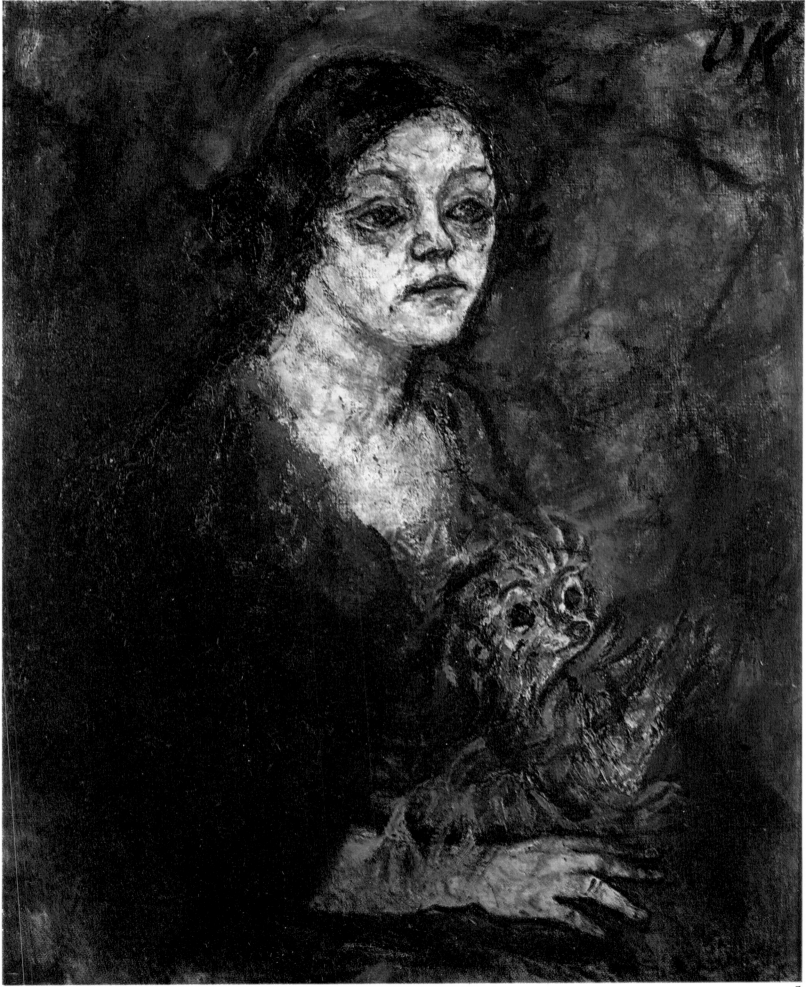

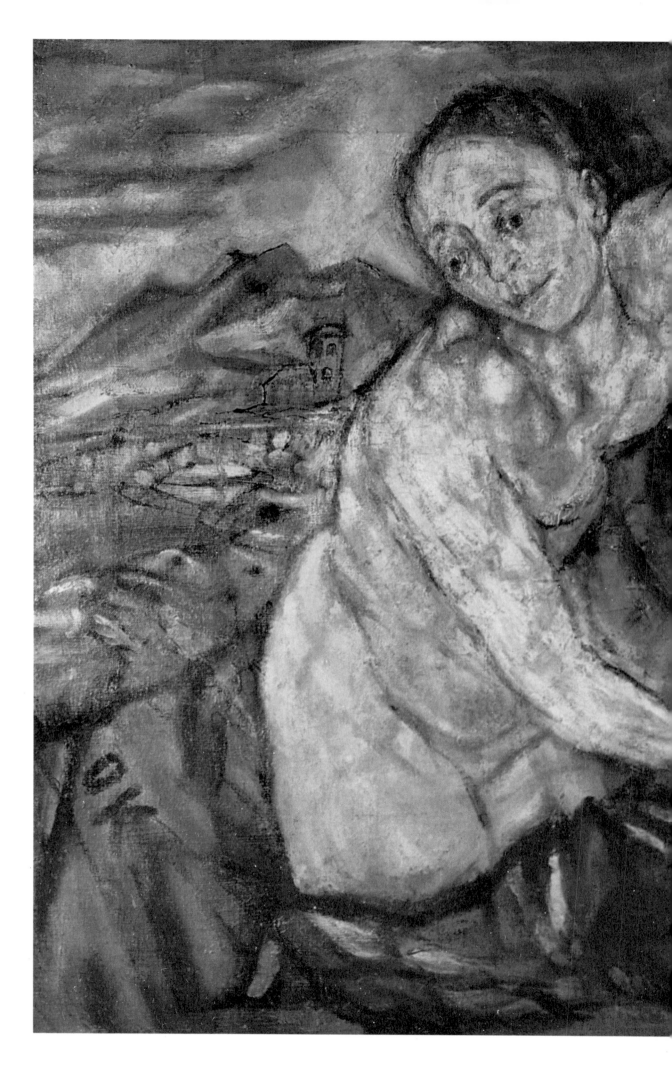

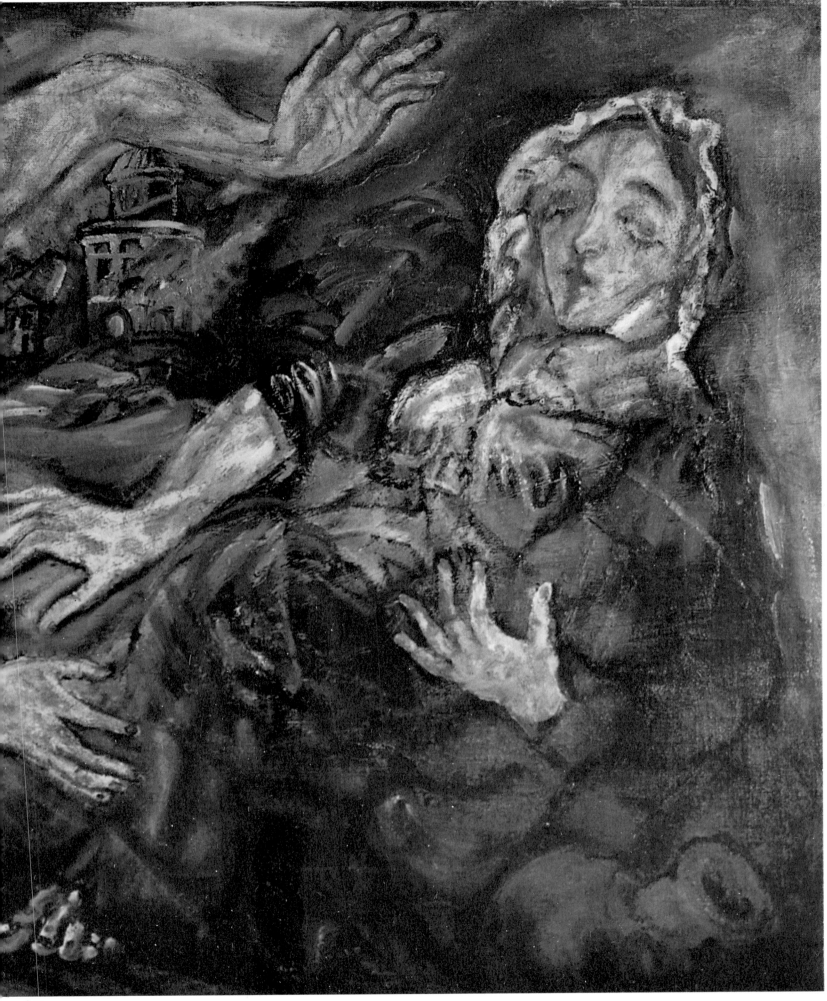

6-7

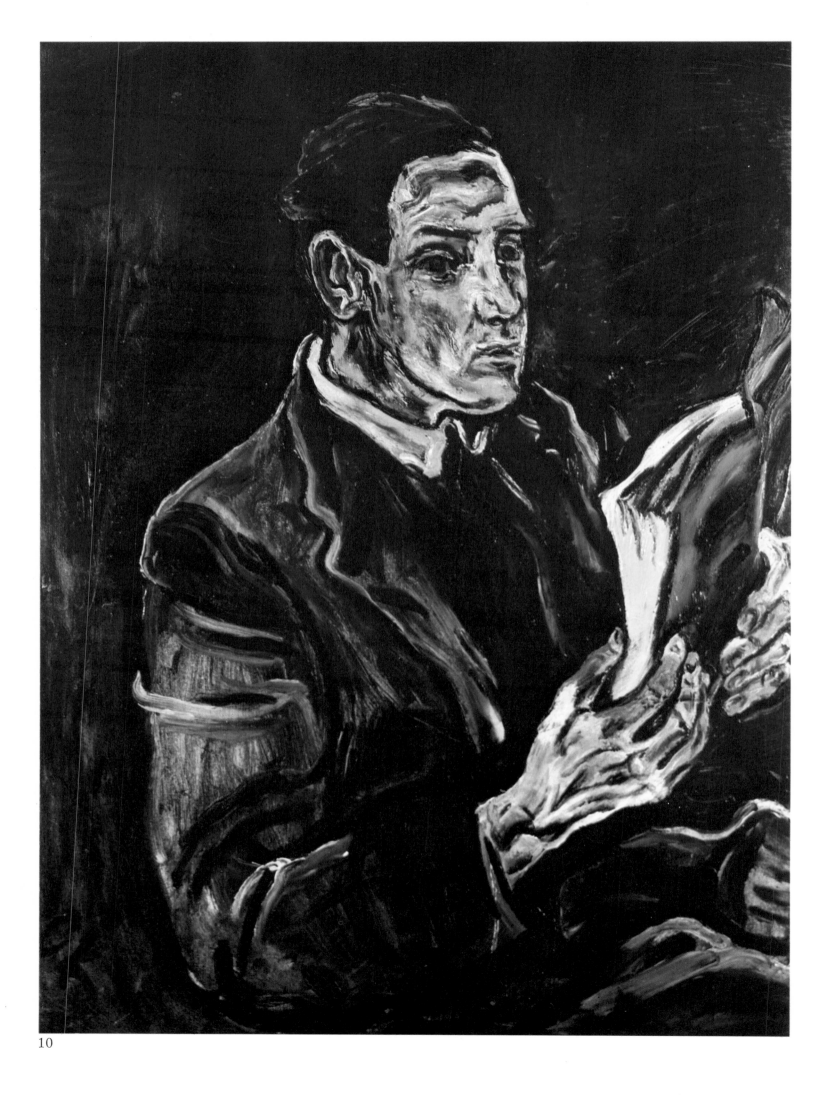

10

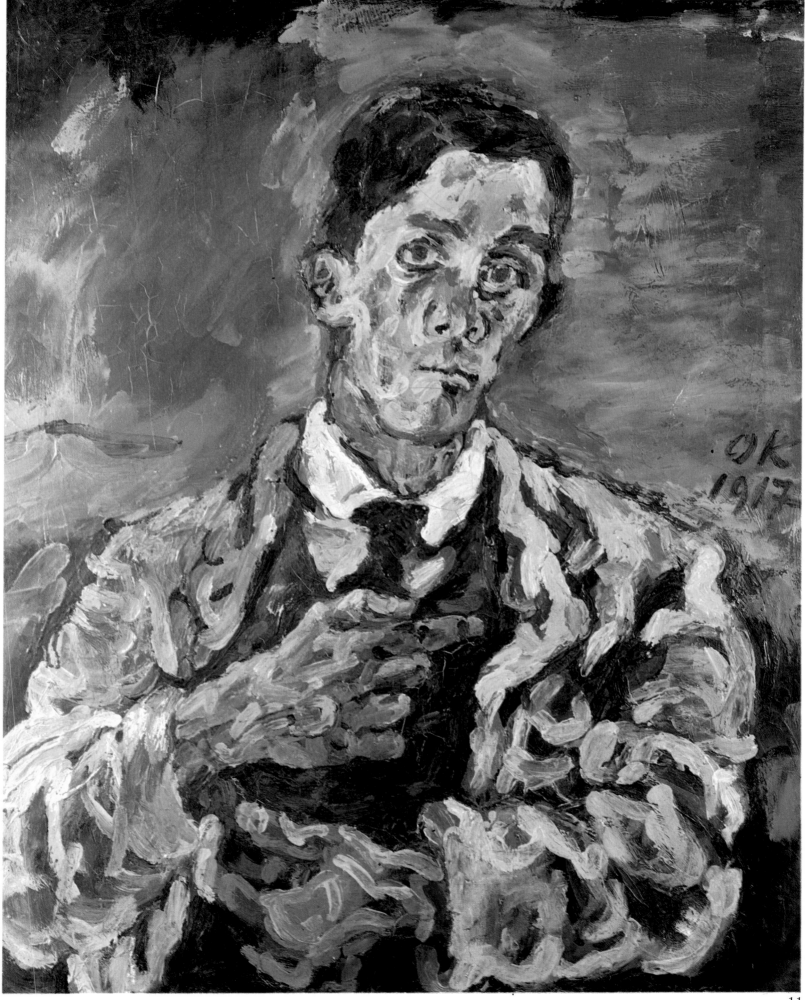

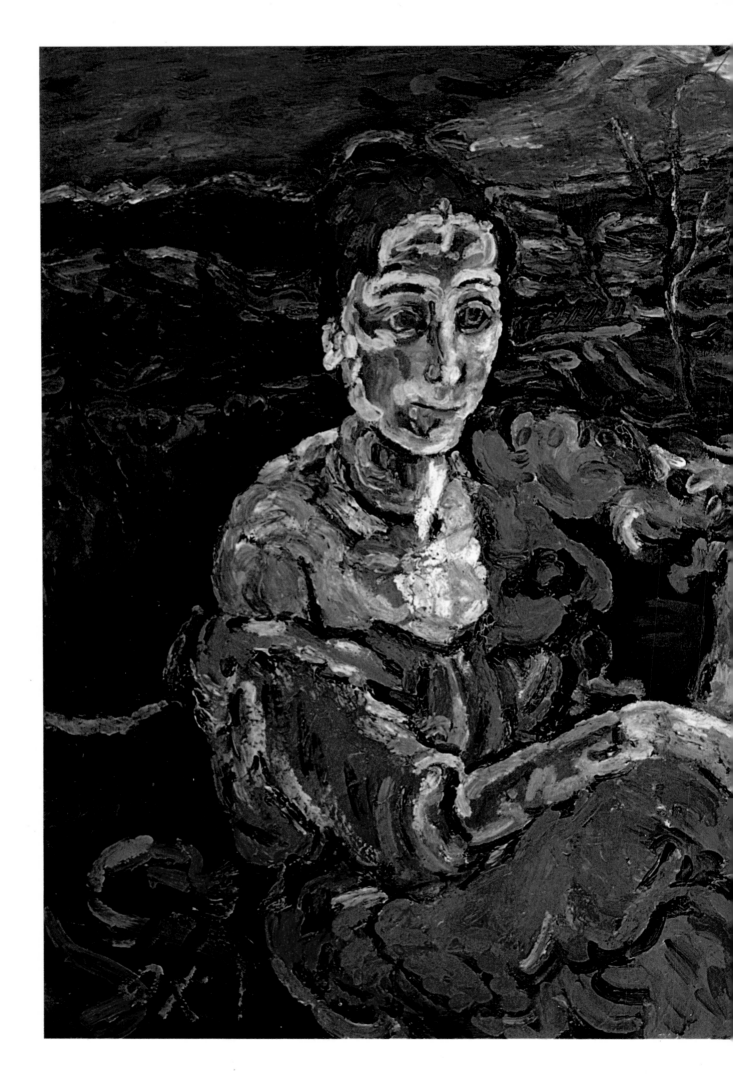

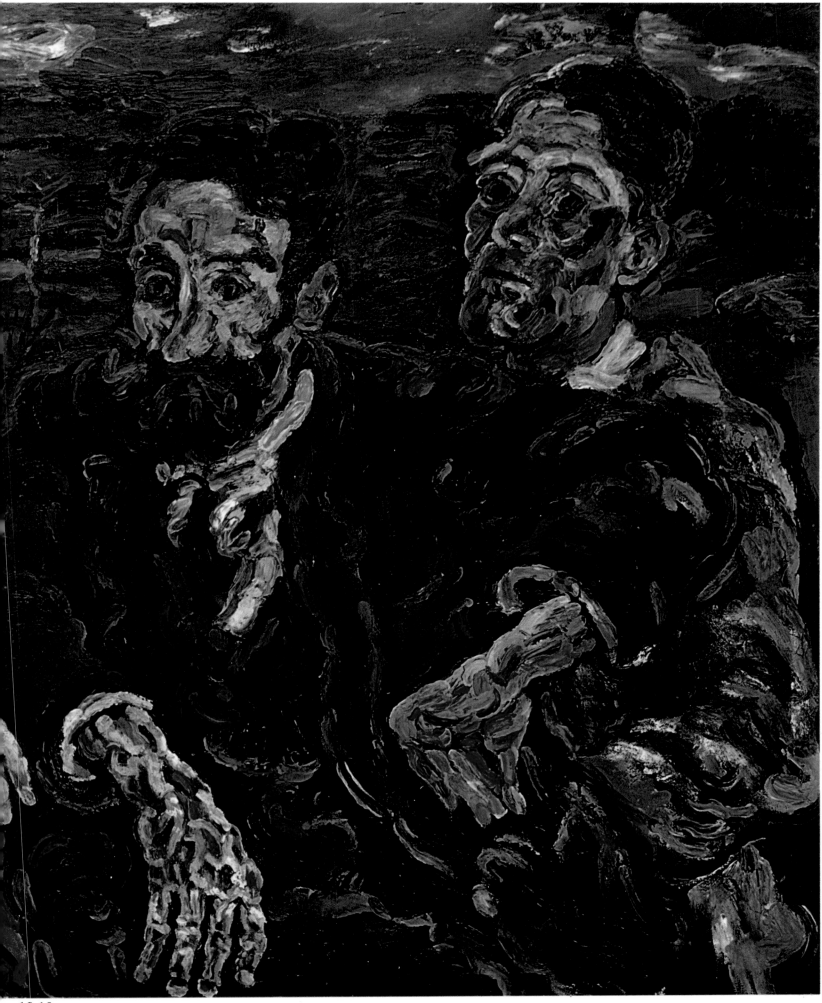

12-13

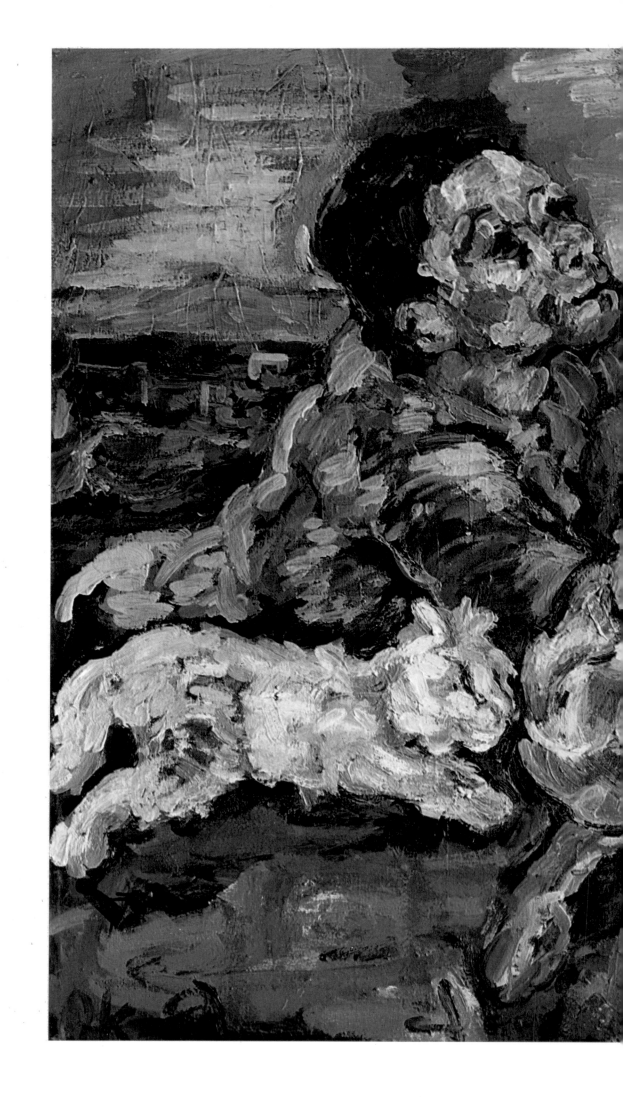

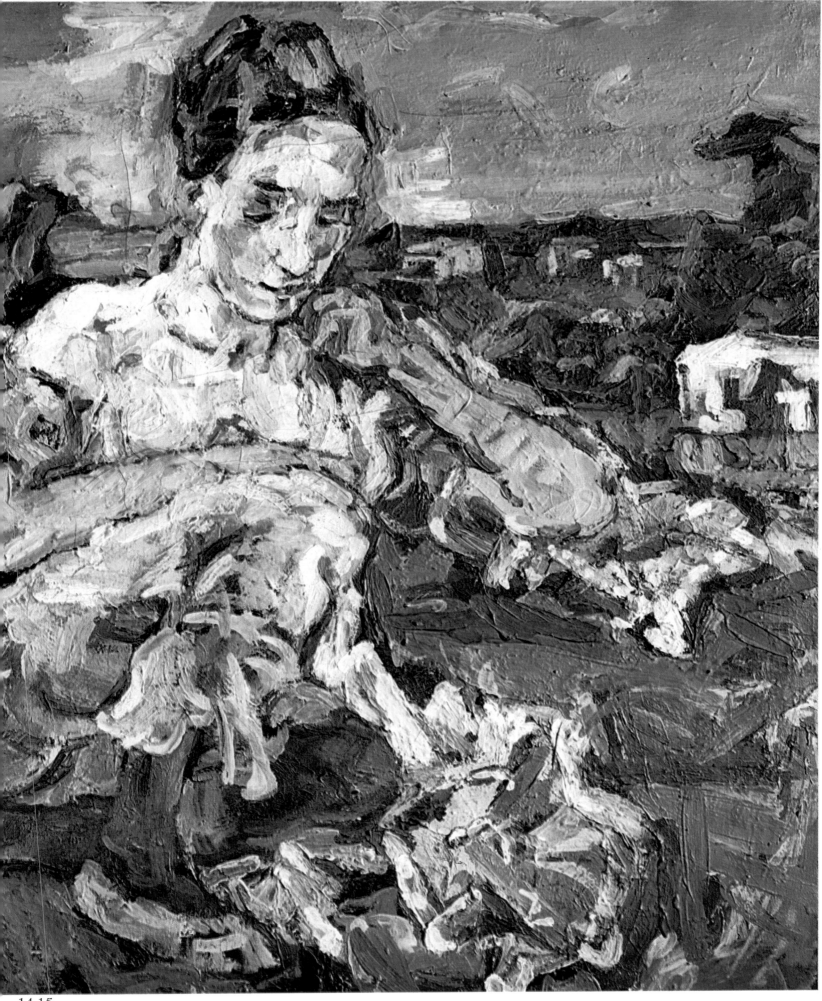

14-15

16

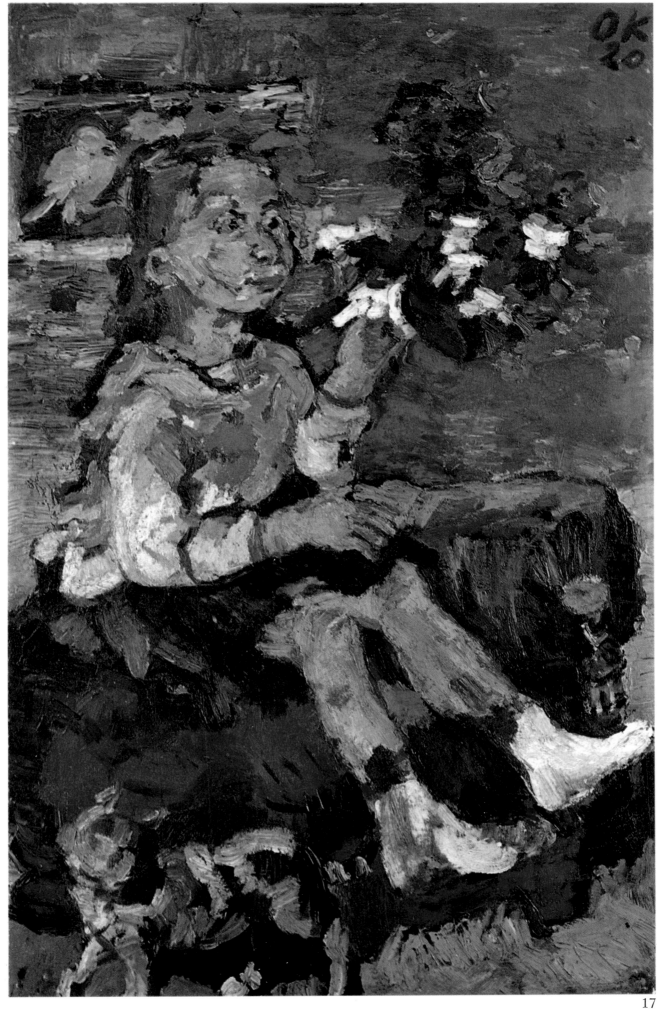

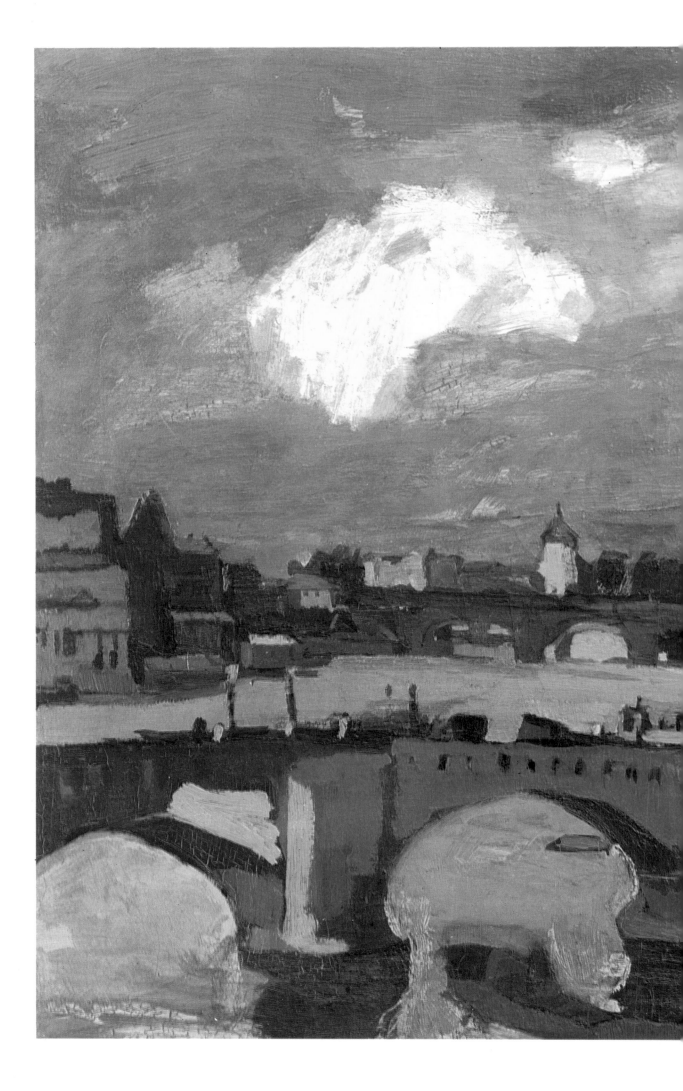

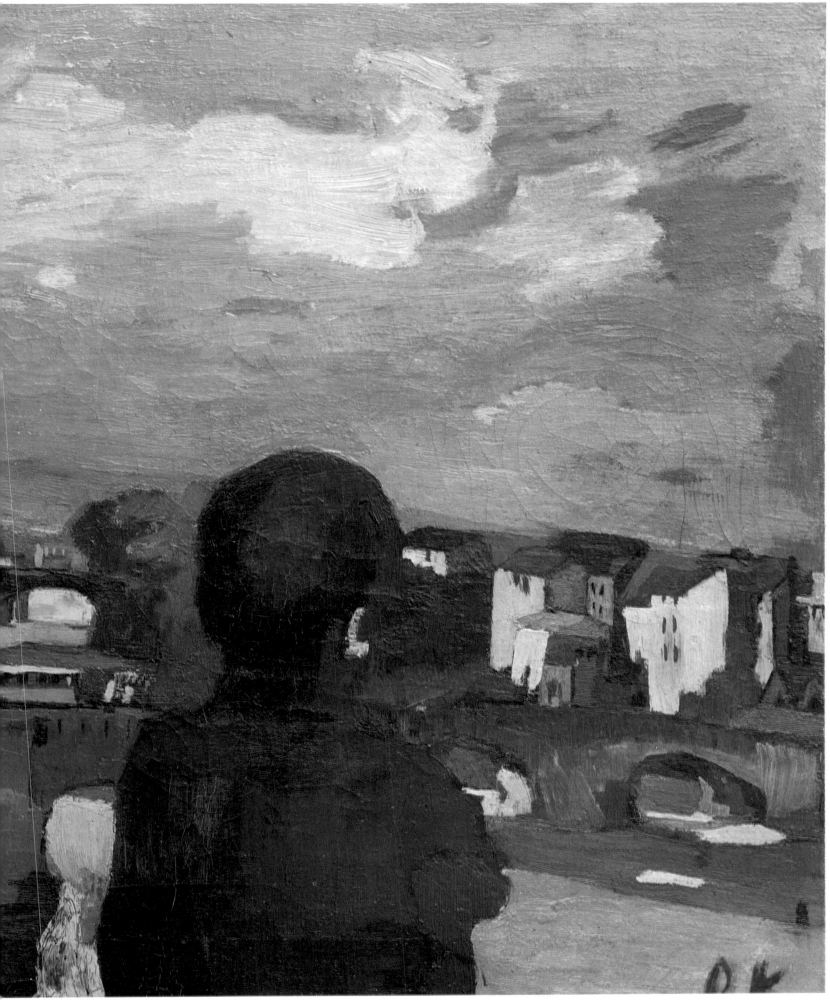

18-19

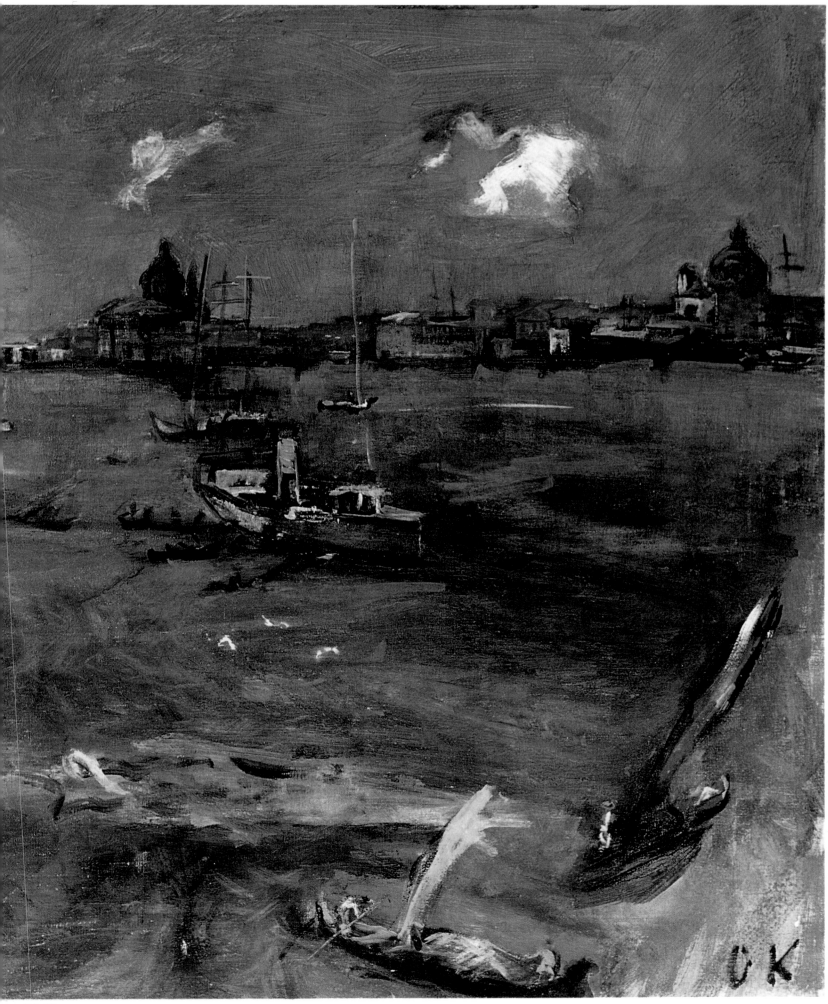

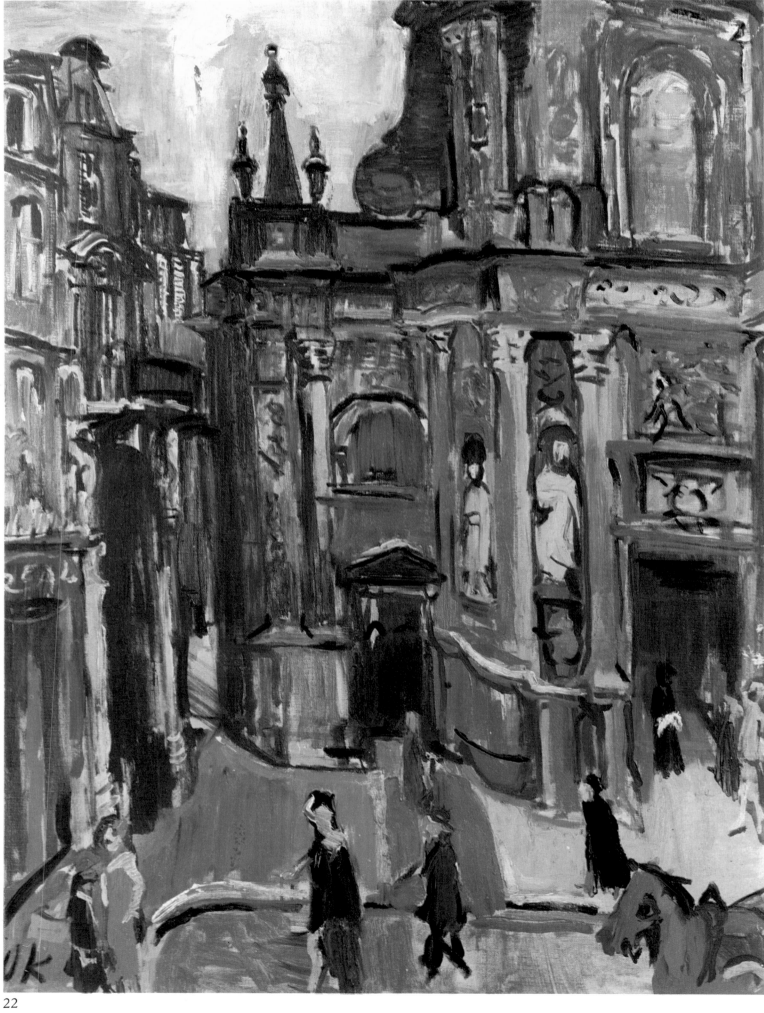

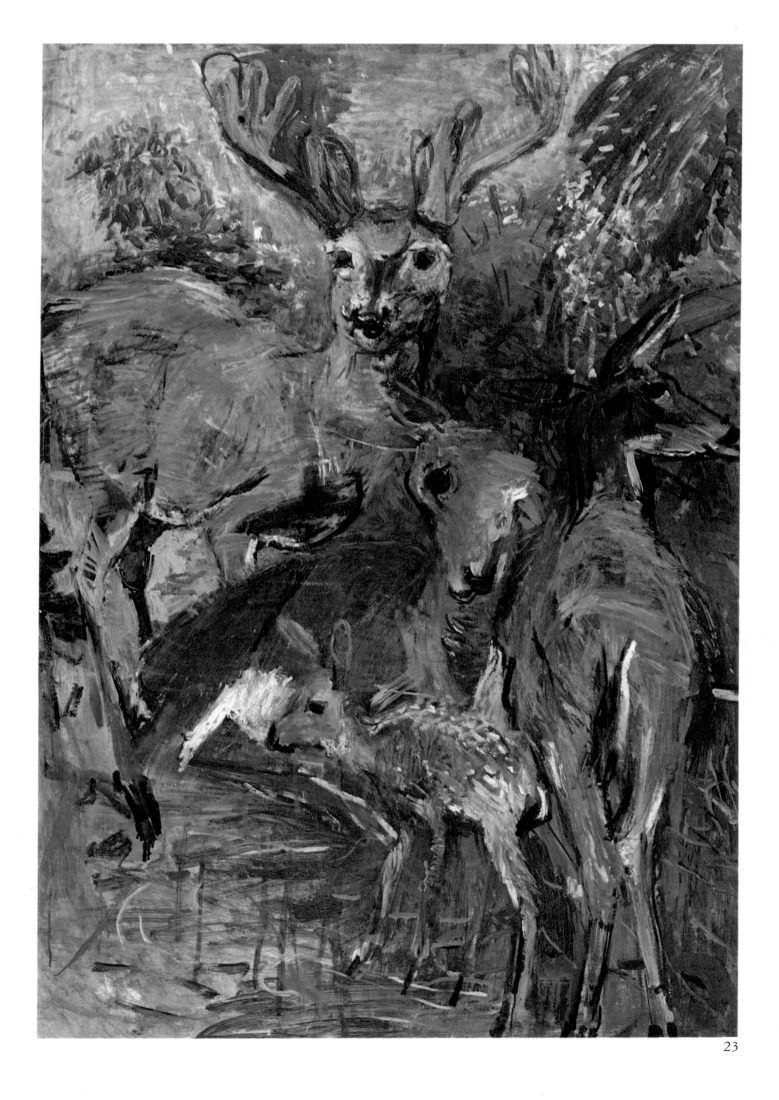

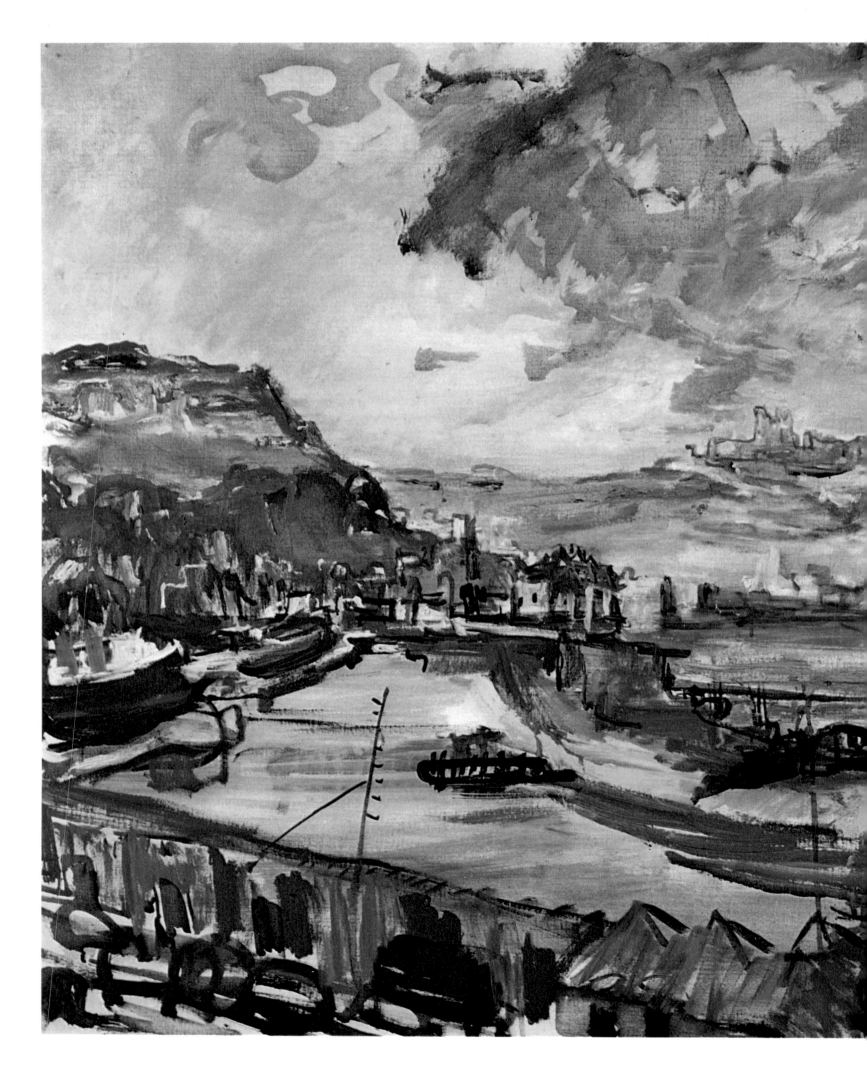

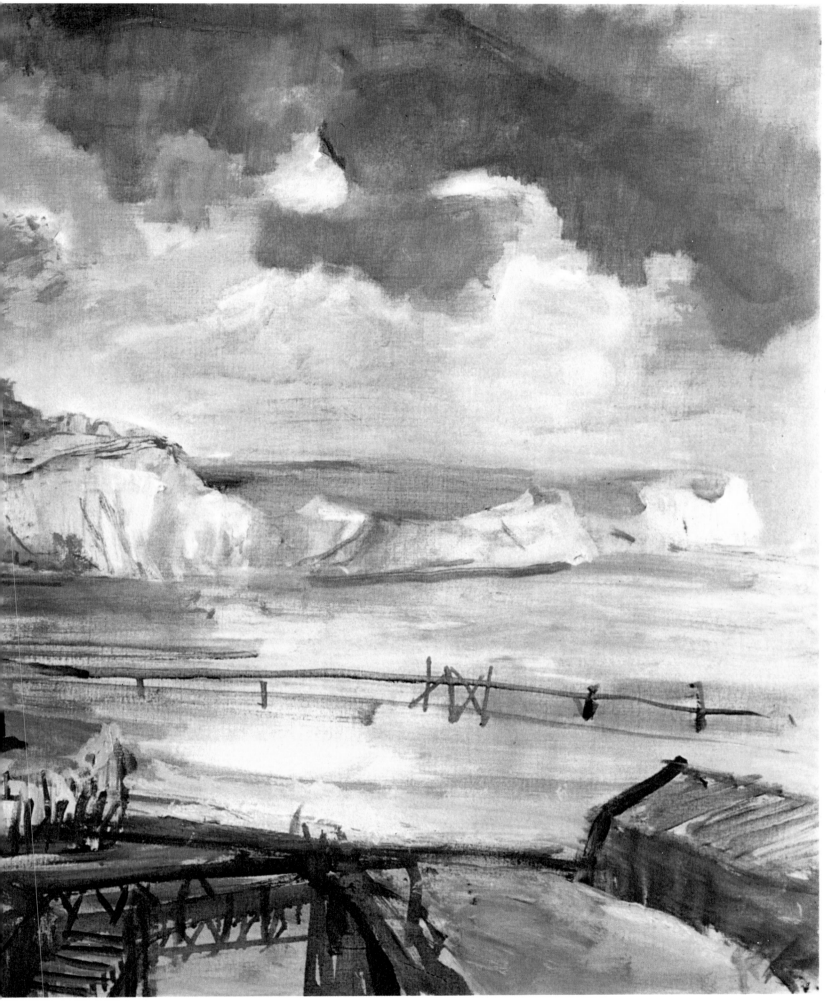

24-25

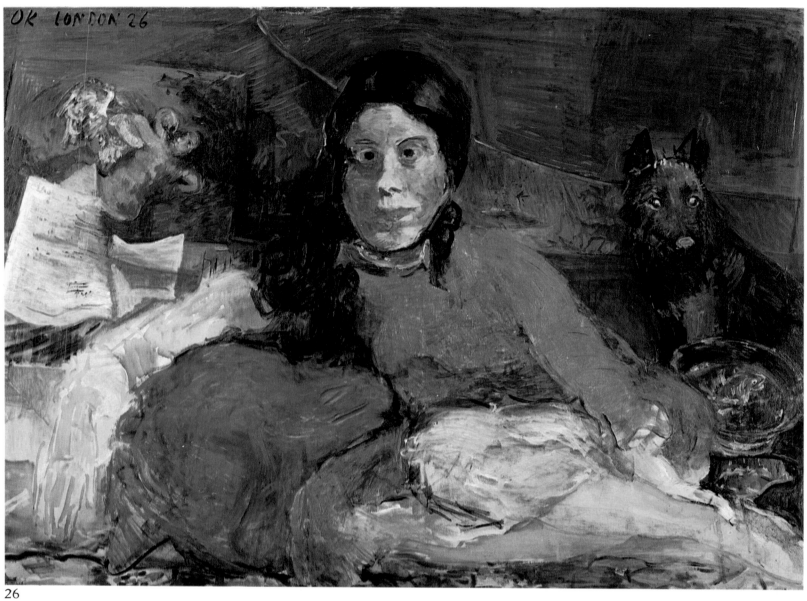

26

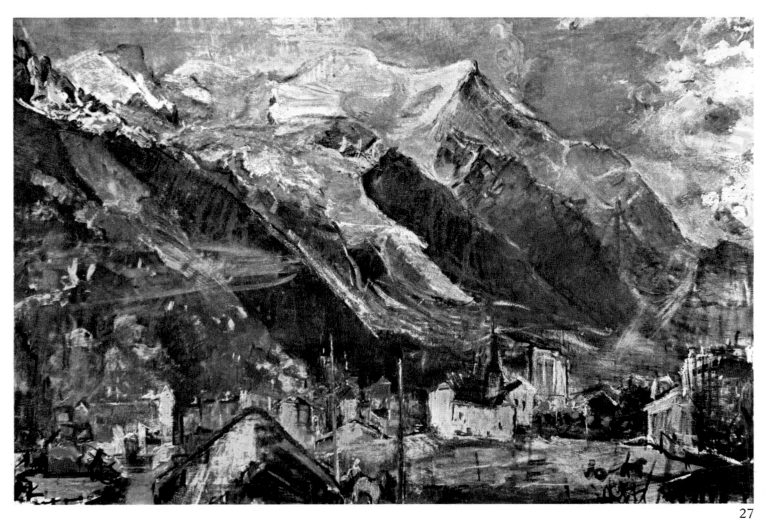

27

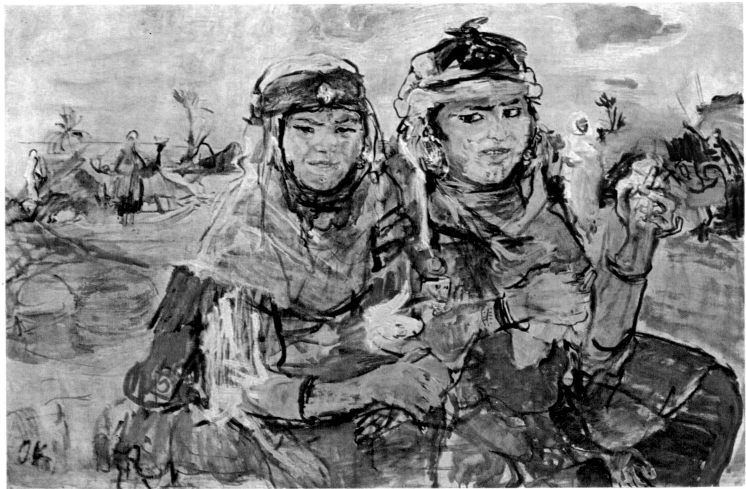

28

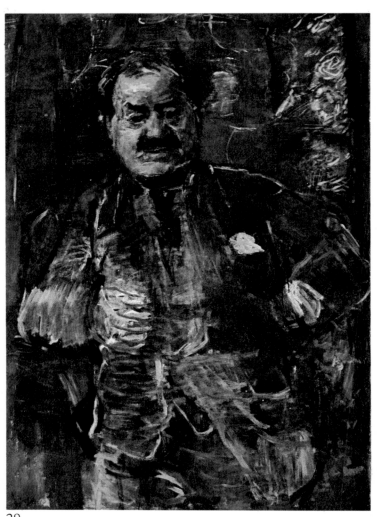
29

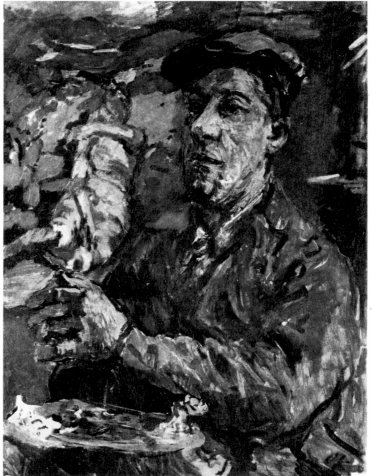
30

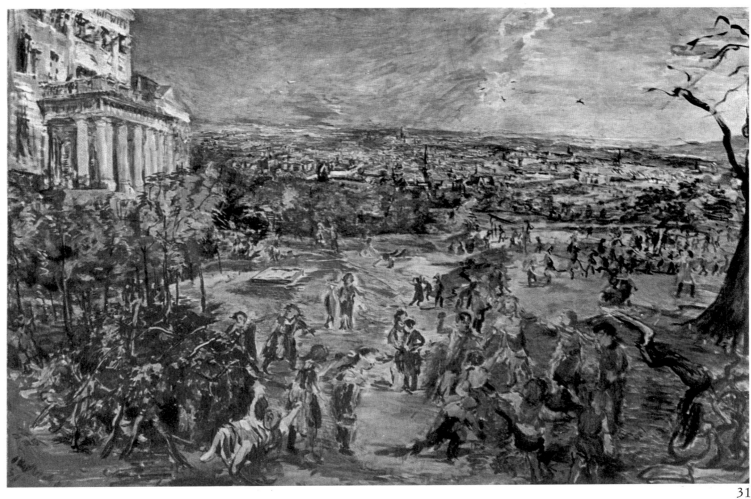

31

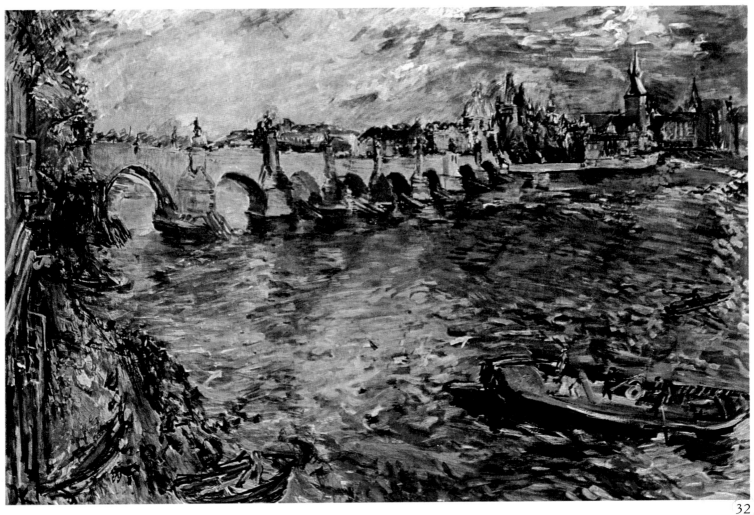

32

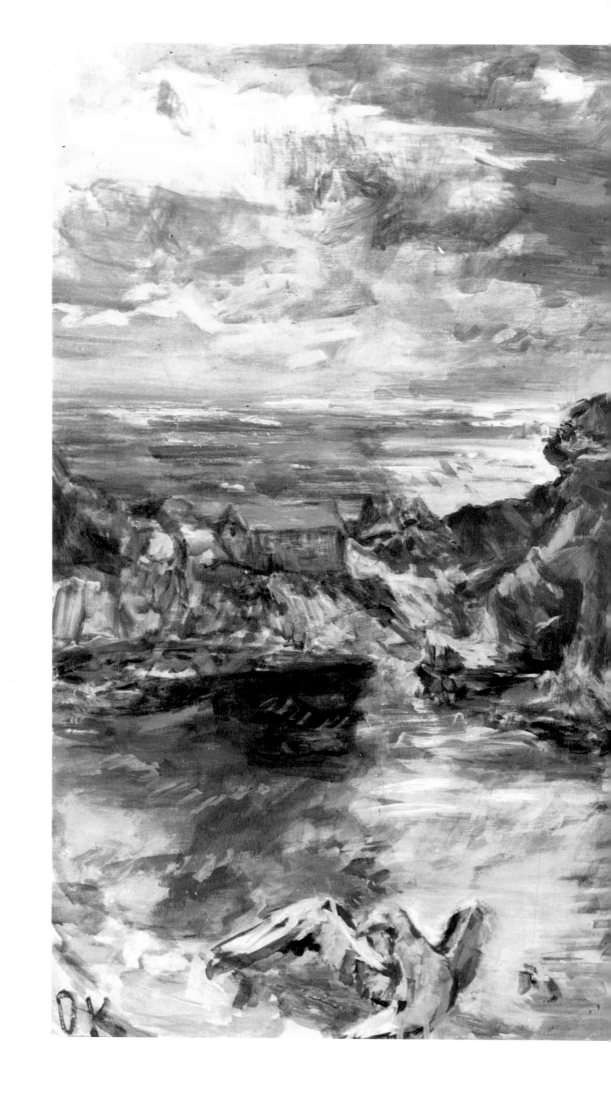

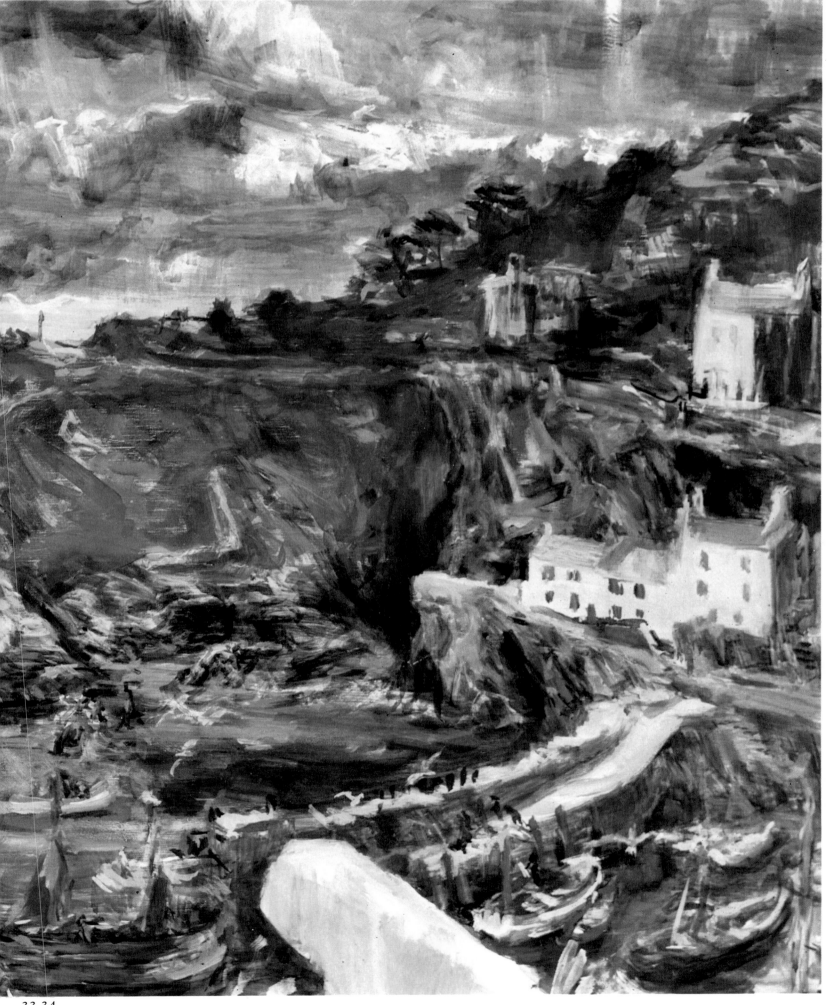

33-34

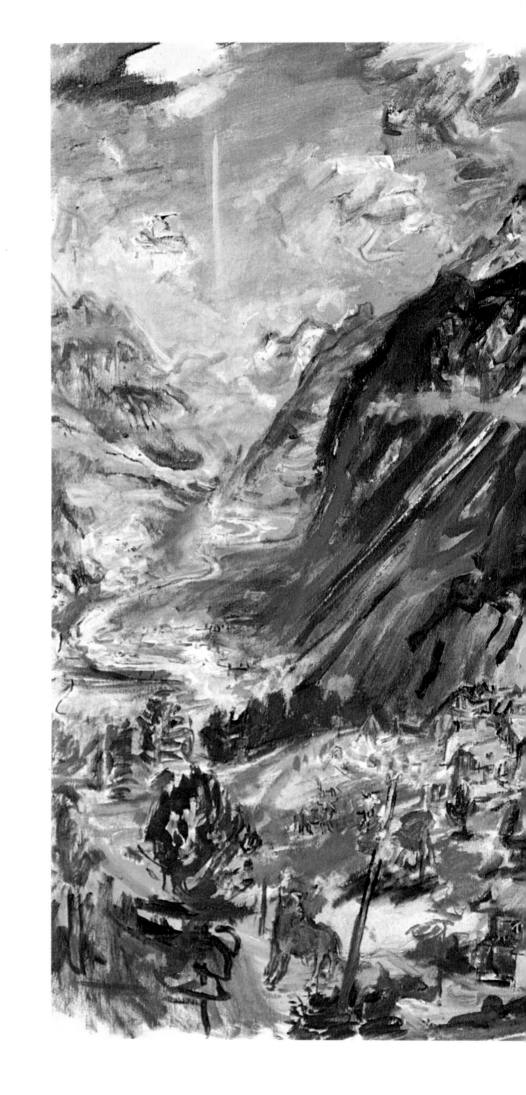

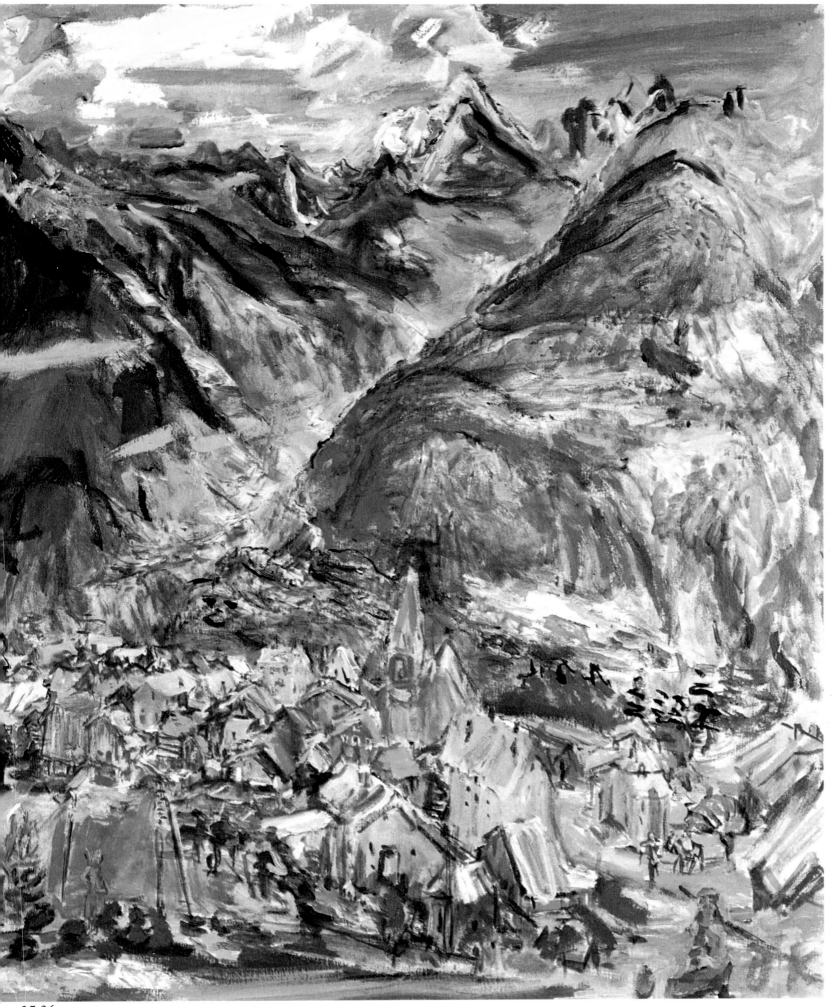

35-36

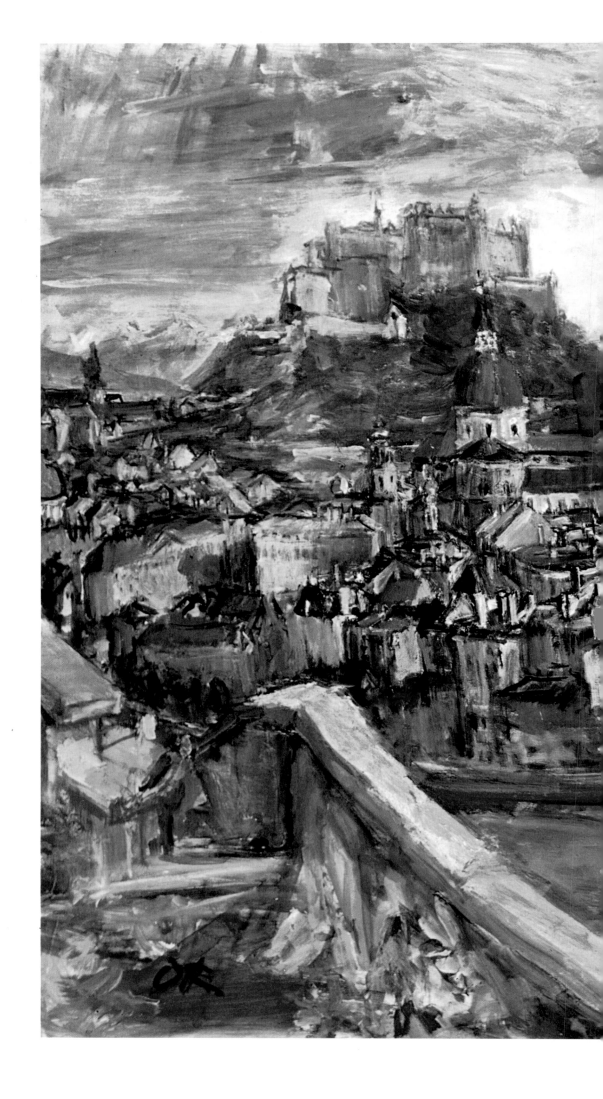

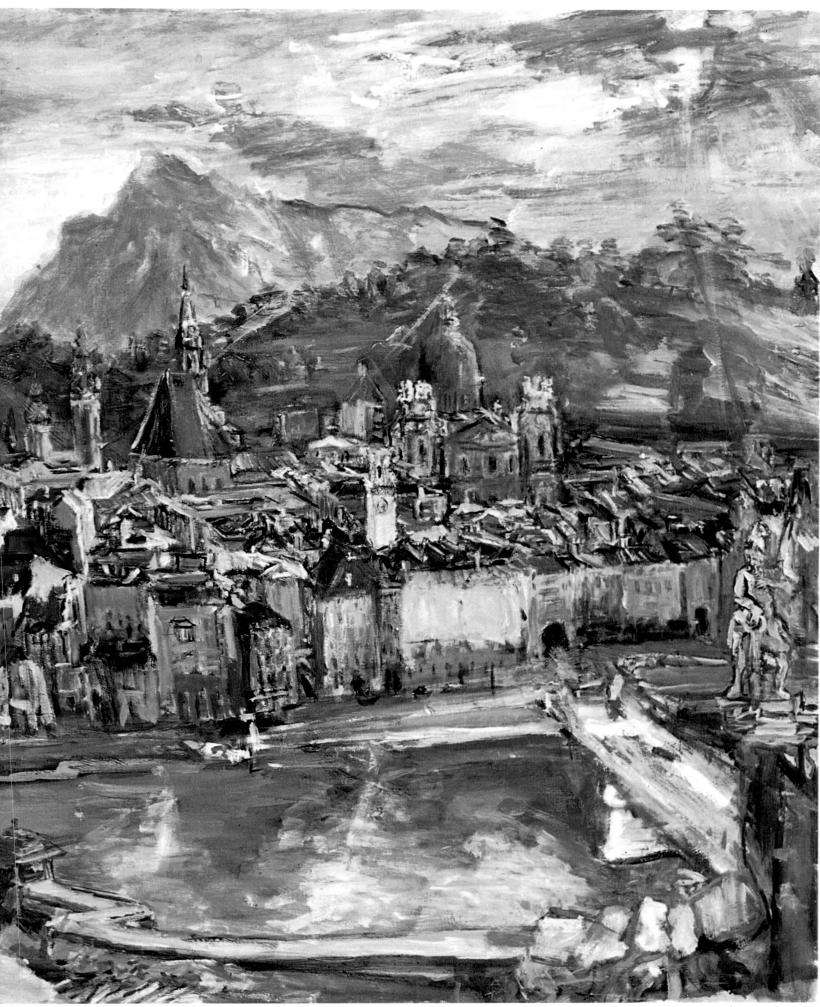

37-38

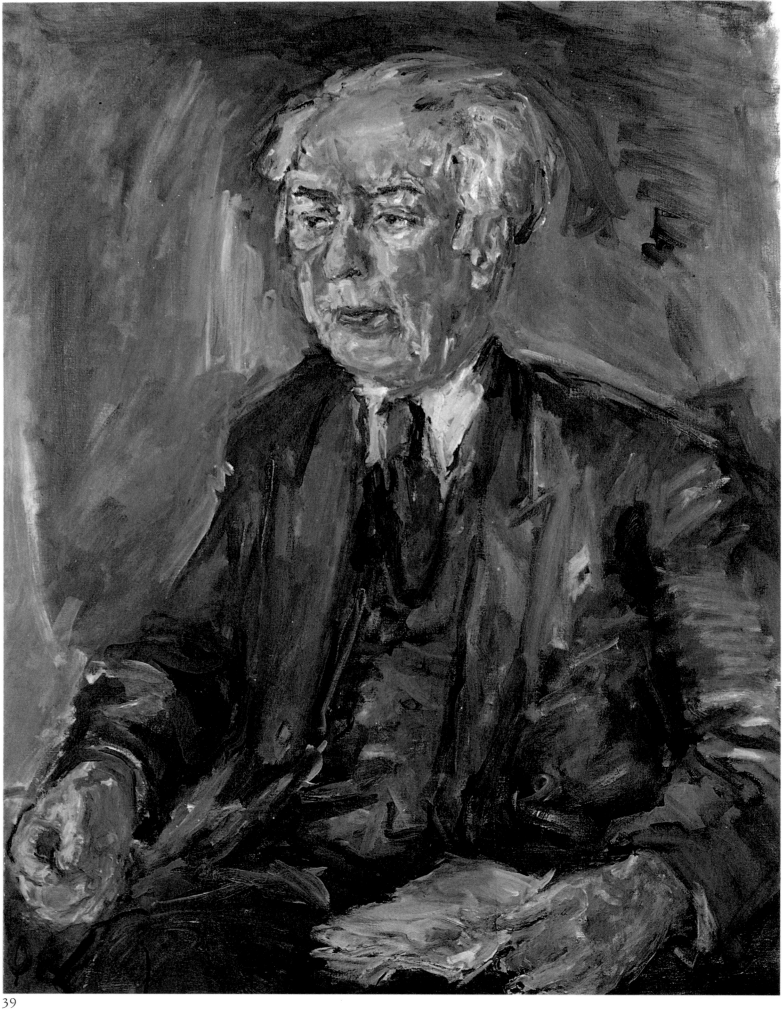

39

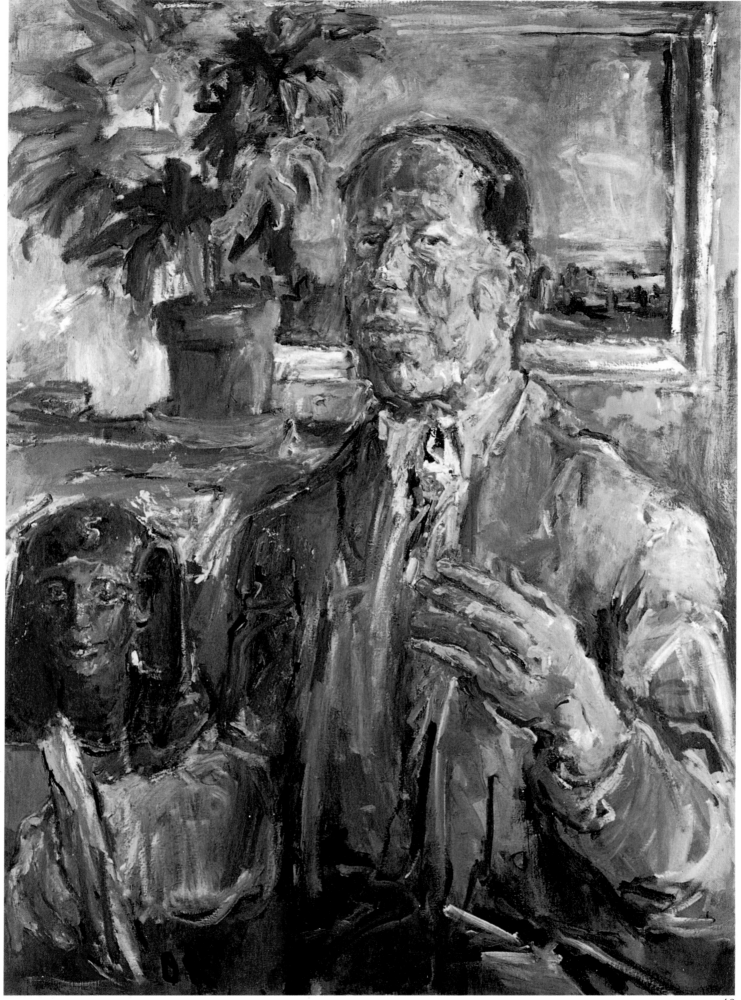

41

Description of colour plates

1 *Player in a Trance*
c. 1908, oil on canvas, 33 × 25½ in (84 × 65 cm)
Musées Royaux des Beaux Arts, Brussels

2 *Winter Landscape, Dent du Midi*
1909, oil on canvas, 30 × 45¾ in (76 × 116 cm)
Private collection, Zürich

3 *Portrait of Helene Kann*
1909–10, oil on canvas, 27½ × 19¾ in (70 × 50 cm)
Kunsthaus, Zürich

4 *Portrait of Herwarth Walden*
1910, oil on canvas, 39¾ × 26¾ in (100 × 68 cm)
Private collection, Minneapolis

5 *Portrait of Else Kupfer*
1910, oil on canvas, 35½ × 28 in (90 × 71 cm)
Kunsthaus, Zürich

6-7 *The Annunciation*
1911, oil on canvas, 32¼ × 48 in (82 × 122 cm)
Private collection, Bochum

8-9 *The Tempest* (original title: *The Large Boat*)
1914, oil on canvas, 71¼ × 87 in (181 × 221 cm)
Kunstsammlung, Basle

10 *Man Reading* (or *Portrait of J. H.*)
c. 1914, oil on canvas
Unknown collection

11 *Self-portrait*
1917, oil on canvas, 30¾ × 24½ in (78 × 62 cm)
Private collection, Wuppertal

12-13 *The Emigrants*
1916-17, oil on canvas, 37 × 57 in (94 × 145 cm)
Neue Pinakothek, Munich

14-15 *Pair of Lovers with a Cat*
1917, oil on canvas, 36½ × 54 in (93 × 137 cm)
Kunsthaus, Zürich

16 *Woman in Blue*
1919, oil on canvas, 29½ × 39½ in (75 × 100 cm)
Württembergische Staatsgalerie, Stuttgart

17 *Little Girl with Flowers and a Cat*
1920, oil on canvas, 50¾ × 33 in (129 × 84 cm)
Neue Pinakothek, Munich

18-19 *Dresden, Bridge over the Elbe*
1923, oil on canvas, 25½ × 35½ in (65 × 90 cm)
Museum Folkwang, Essen

20-21 *Venice, Boats at the Dogana*
1924, oil on canvas, 29½ × 37¼ in (75 × 95 cm)
Bayerische Staatsgemäldesammlungen, Munich

22 *Bordeaux Cathedral*
1924-25 oil on canvas, 31½ × 23½ in (80 × 60 cm)
Private collection, Vancouver

23 *Roebucks*
1926, oil on canvas, 51¼ × 35 in (130 × 89 cm)
Private collection, U.S.A.

24-25 *The Coast near Dover*
1926, oil on canvas, 30 × 50 in (76.5 × 127.5 cm)
Kunstsammlung, Basle

26 *Portrait of Adele Astaire* (Lady Cavendish)
1926, oil on canvas, 37¾ × 51½ in (96 × 131 cm)
Kunsthaus, Zürich

27 *Chamonix, Mont Blanc*
1927, oil on canvas, 35½ × 51¼ in (90 × 130 cm)
Private collection, Küsnacht

28 *Arab Women*
1928, oil on canvas, 35 × 51¼ in (89 × 130 cm)
Private collection, Zürich

29 *Portrait of Marcel von Nemeš*
1929, oil on canvas, 53 × 37¼ in (135 × 95 cm)
Neue Galerie der Stadt Linz, Linz

30 *Self-portrait with a Cap*
1932, oil on canvas, 38½ × 28 in (98 × 71 cm)
Private collection, Epsom (Surrey)

31 *Vienna: View from the Wilhelminenberg*
1931, oil on canvas, 36¼ × 53½ in (92 × 136 cm)
Historisches Museum der Stadt Wien, Vienna

32 *Prague, Karlsbrücke*
1934, oil on canvas, 34¼ × 48 in (87 × 122 cm)
National Gallery, Prague

33-34 *Polperro, Cornwall, II*
1939, oil on canvas, 23½ × 33½ in (60 × 85 cm)
Tate Gallery, London

35-36 *Landscape in Montana*
1947, oil on canvas, 35½ × 47¼ in (90 × 120 cm)
Kunsthaus, Zürich

37-38 *View of Salzburg*
1950, oil on canvas, 31½ × 47¼ in (80 × 120 cm)
Bayerische Staatsgemäldesammlungen, Munich

39 *Portrait of Theodor Heuss*
1950, oil on canvas, 41¼ × 31½ in (105 × 80 cm)
Wallraf-Richartz-Museum, Cologne

40 *Portrait of Emil Bührle*
1951-52, oil on canvas, 49¼ × 35½ in (125 × 90 cm)
E. G. Bührle Foundation, Zürich

41 *The Feilchenfeldt Brothers*
1952, oil on canvas, 35½ × 53 in (90 × 135 cm)
Private collection, Zürich

Biographical outline

The life of Oskar Kokoschka has been so full and busy that it is hard to give a complete and exact account of it. Hans M. Wingler, in his fundamentally important monograph on Kokoschka's painting (Oskar Kokoschka, Das Werk des Malers, Verlag Galerie Welz, Salzburg, 1956), gave a careful comparative table of events in his life and work from 1886 to 1956, and more detailed information about this period should be sought there. The summary that follows, however, gives a fairly clear idea of the passionate and many-sided activity which Kokoschka has contributed to Western culture during a lifetime conspicuous for its moral rectitude and sense of civic responsibility.

In collecting the information about the recent years of his life, I have been much helped by Giorgio Capezzani, whom I should like to thank.

Kokoschka was born at Pöchlarn (Danube) on 1st March, 1886, the second of four sons. His father came from Prague and his mother originally from Styria. When he was a child the family moved to Vienna, where his elder brother died in 1891.

In 1904 he graduated from a state school, planning to study chemistry, but instead he went to the Vienna School of Arts and Crafts from 1905–09 under the tutelage of Von Kenner, Czeschka and Löffler. In this period he was probably indirectly influenced by Klimt.

In 1905, he began to paint in oils, and at the same time continued to draw. In the same year he was much interested in the retrospective exhibition of Anton Romako, who had died in 1889. The following year Kokoschka had an opportunity of seeing the work of Van Gogh, and was also attracted to the art of eastern Asia. He continued with his oil painting but did more drawing: he drew in a very linear and objective way, in complete contrast to the excess of decoration then in fashion.

In 1907 he worked at the Wiener Werkstätte (where, among other things, he painted fans) and collaborated in founding the Cabaret Fledermaus (*The speckled egg* – figures for Chinese shadows). He also made studies of movement, and did sketches for postcards and coloured lithographs. Very likely the two oil paintings *Still-life with Pineapple* and *Papa Hirsch* belong to this year. He wrote the poem *Die Träumenden Knaben* ('Dreaming Youths') published the following year, and the plays *Sphinx und Strohmann* ('Sphinx and Strawman') and *Mörder, Hoffnung der Frauen* ('Murder, Hope of Women') which started the Expressionist theatre in Germany.

Murder, Hope of Women, for which he did many designs (published in *Der Sturm*), was first performed at the open-air theatre of the Kunstschau in 1908. For the first time he used superimposed portraits in profile and full face. He painted a portrait of the actor Ernst Reinhold (the main character of *Murder, Hope of Women*), known as *Player in a Trance*, and followed it with portraits of Mrs Hirsch and Karl Kraus. He met the architect Adolf Loos (author of *Ornament and Crime*), who introduced him to the literary circle of Peter Altenberg and Karl Kraus and got him a few private commissions. At the Internationale Kunstschau in Vienna he exhibited designs for tapestries, the book *Die Träumenden Knaben*, a piece of sculpture and some graphic studies.

In 1909 he took part again in the Internationale Kunstschau, with the portrait of Reinhold and illustrations for the poem *Der Weisse Tiertöter* ('The White Hunter') written in the same year, whose title was later changed to *Der Gefesselte Kolumbus* ('The Fettered Columbus'). In March *Sphinx und Strohmann* was put on at the Cabaret Fledermaus. He painted portraits of Adolf Loos and Christomanos, *Boy with his Hand Raised,* and *Still-life with Sheepskin and Hyacinths:* then followed portraits of Janikowsky, Mr and Mrs Tietze, Bessie Loos and Count Verona, painted in Switzerland. He belonged fully to Loos's circle, and left the Wiener Werkstätte and the School of Arts and Crafts.

1910 was the year in which his relationship with the gallery of Paul Cassirer began. In June, his first one-man show was put on there and received very favourable criticism from Kurt Hiller in

Der Sturm and from Grüner and Tesar in *Die Fackel*. He painted many portraits, among them those of Walden, Scheebart, Forel, Blumner, and the actress Tilla Durieux, Cassirer's wife. *Der Sturm*, by publishing engravings taken from his drawings, introduced what were called 'simultaneous drawings' to a wide public, and in July distributed tens of thousands of copies of *Murder, Hope of Women*, which influenced the new-born Expressionist theatre profoundly. He travelled in Switzerland and to Berlin and the Rhineland. The Folkwang Museum of Essen, Westphalia, put on a one-man show.

In 1911 he was appointed assistant teacher at the School of Arts and Crafts in Vienna. He met Hermann and Eugenie Schwarzwald and became a friend of Alma Mahler, Gustav Mahler's widow. He drew for *Der Sturm*, illustrated Ehrenstein's *Tubutsch* and wrote *Der Brennende Dornbusch* ('The Burning Bush'), the original title of which was *Schauspiel* ('Performance'). In the spring he exhibited twenty-five works at the Hagenbund in Vienna; the exhibition was harshly attacked by critics in the press, but Lasker-Schuler in *Der Sturm* and Grüner and Kraus in *Die Fackel* wrote enthusiastically about it. He painted a portrait of Dirsztay and one of Schwarzwald (I); *The Flight into Egypt* and *Golgotha* probably belong to the same year.

In 1912 he gave up teaching at the School of Arts and Crafts in Vienna and in March took part in an exhibition at the Sturm Gallery in Berlin with artists of the Blaue Reiter group. In May he showed six works at the Sonderbund westdeutscher Kunstfreunde und Künstler in Cologne. He painted portraits and nudes. One of his works was bought by the Wallraf-Richartz-Museum in Cologne. He designed the hand-out for his lecture *Von der Natur der Gesichte* ('On the Nature of Visions') at the Akademischer Verband für Literatur und Musik (26th January, 1912). Marc and Kandinsky reproduced the portrait of Else Kupfer in *Der Blaue Reiter*.

In 1913, after teaching drawing in a private school, he travelled in Italy with Alma Mahler, from whom he parted the following year. He was strongly influenced by the paintings of Tintoretto and painted *Naples During a Storm* and *Dolomite Landscape with Three Crosses*. He illustrated Karl Kraus's book *Die Chinesische Mauer* ('The Chinese Wall') with lithographs, and made lithographs for his own book *Der Gefesselte Kolumbus*. At the Erster Deutscher Herbstsalon in Berlin he exhibited a group of drawings. He wrote a poem, *Alos makar* (an anagram of Alma and Oskar), which was published in *Zeitecho* in 1915, and published his book *Dramen und Bilder,* ('Plays and Paintings'), with a preface by P. Stefan.

In 1914 Austria entered the First World War and Kokoschka joined up in the cavalry, although he continued drawing and painting a great deal. *The Tempest*, exhibited at the Neue Münchner Sezession in June, and *Self-portrait with a Brush*, were painted during this year. At the beginning of 1915 he painted the portrait of Ludwig von Ficker and with Marc and Campendonk held an exhibition at the Berlin gallery of *Der Sturm*. At the beginning of September, 1915, on the front at Galicia, he was seriously wounded (head injury and bayonet wound in the lung) and sent to hospital, where he began the play *Orpheus und Eurydice*.

The early months of 1916 were spent convalescing in Vienna, where he met Hofmannstal and Rilke. He painted a second portrait of Dr Schwarzwald and had started one of the Dietrichstein family when he was called up again and sent to the front at Isonzo, where he stayed until August; there he drew landscapes and portraits. Back in Vienna in the autumn, he went to Berlin on the invitation of *Der Sturm;* there he painted portraits of Nell Waldron and Mechthild Lichnowsky and drew for the Movement's magazine. Gurlitt published his illustrations for *Der Gefesselte Kolumbus* and *O Ewigkeit, Du Donnerwort* ('O Eternity, You Shining Word'). *Der Sturm*, which had organised Kokoschka's exhibition in April, brought out a new edition of *Murder, Hope of Women* and published his drawings *Menschenköpfe* ('Human Heads'). He became friendly with Käthe Richter and renewed his contract with Cassirer.

1917 was a year of profound physical and spiritual distress, during which he spent a long time recovering in Stockholm and Dresden, where he studied the great masters of the past, Rembrandt in particular, and was intensely busy drawing and painting in

watercolours and oils. He finished his painting *The Emigrants,* which he had begun in 1916, painted *Lovers with a Cat, The Port of Stockholm* and the *Wuppertal Self-portrait,* and began *The Friends. Sphinx und Strohmann* (from 1907) was substantially re-elaborated and published under the title *Hiob* ('Job'). At the Dada Gallery in Zürich in April an important exhibition was held which included works by Kokoschka, Max Ernst, Paul Klee, Kandinsky, and *Sphinx und Strohmann* was performed. Westheim and Hoffmann wrote about his dramatic work which for the first time was given proper critical recognition.

During the whole of 1918 his spiritual and physical prostration continued. Yet he worked furiously: he finished *The Friends,* painted more pictures, made the etchings for *Orpheus und Eurydice* (not published) and the great lithograph portraits published by Cassirer. He met the art historian Hans Posse, with whom he went to live the following year. Gurlitt published his *Bachkantate* ('Bach Cantata'). At the end of the year he had an exhibition of thirty paintings and eleven lithographs at the Cassirer Gallery in Berlin and the first monograph on his art (by Westheim) appeared.

In 1919, although he had no exhibitions, Kokoschka produced works of great interest, among them *Woman in Blue,* for which he used a mannequin commissioned the previous year; but the experience with this doll was, as he admitted himself, rather disappointing. In a single book entitled *Vier Dramen* ('Four plays') Cassirer brought together and published *Der Brennende Dornbusch, Murder, Hope of Women, Orpheus und Eurydice* and *Hiob.* In the autumn, Kokoschka was asked to teach at the Dresden Academy and was given a studio in the Brühschen Terrasse. In *Genius* he published 'Vom Bewusstsein der Gesichte' ('On the Awareness of Visions') and made a series of lithographic portraits and water-colours.

During his time in Vienna, in the spring of 1920, Kokoschka painted *Little Girl with Flowers and a Cat* and *Woman with Slave,* and also did some important graphic work: more lithographic portraits, drawings and the Konzert cycle *Variationen über ein Thema,* ('Variations on a Theme'), published in 1921. In August, at the Lang Gallery in Darmstadt, he had a one-man show of his graphic works. At the Neues Theater in Frankfurt, two of his plays were performed, the review *Die Gefährten* devoted a special number to his poetry, and *Vorrede zum Orbis Pictus* ('Introduction to Orbis Pictus') appeared in Cassier's almanac. Paul Hindemith set *Murder, Hope of Women* to music.

For the whole of 1921, except for a short period, he taught enthusiastically at the Dresden Academy. He painted two views of the Elbe (he had painted the first in 1919) and again took up water-colours with renewed interest. His graphic work developed vigorously: he produced drawings and lithographs (womens' faces inspired by biblical characters). He organised four one-man shows: in Hanover (Gallery von Garvens), Munich (Gallery Caspari), Dresden (Gallery Richter), and Berlin (Gallery Gurlitt), and in the summer exhibited twenty works at the Künstlervereinigung. His *Variations on a Theme* was published with an introduction by Max Dvořák. *Orpheus und Eurydice* had its first performance at the Schauspielhaus in Frankfurt and Hindemith's *Murder, Hope of Women* was first performed in the Landestheater in Stuttgart. The following year it was performed at the Opernhaus in Frankfurt and at the Staatsoper in Dresden.

In 1922 Kokoschka was invited to exhibit twelve works at the XIII Venice Biennale. He also had a one-man show at the Graphisches Kabinett Erfurth in Dresden, where his complete graphic work was shown. He painted some very important oils (*Lot and his Daughters* [destroyed] *Reclining Woman, Dresden, The New City* (IV and V), *Jacob, Rachel and Leah* etc.,) and continued with his lithographs, with drawings and in particular with watercolours.

In 1923 he had two one-man shows: in Berlin at the Cassirer Gallery and in Zürich at the Kunstsalon Wolfsberg. In *Kunstblatt* he published his story 'Die Schale' ('The Cover') and, through Westheim, the nine letters of 1918–19, 'About the doll', were published in *Künstlerbekenntnisse.* Among others he painted *The Augustus Bridge with a Steamship (I and II), Self-portrait with Folded*

Arms (which Wingler puts in 1922 in his monograph list and in 1923 in the catalogue). *Painter and Model (I), The Persian, The Slave,* and *Little Girl with Flowers.* He also made the colour lithograph *Self-portrait from Both Sides.* Ernst Křenek set *Orpheus und Eurydice* to music.

After 1924 Kokoschka almost entirely lost interest in graphic techniques and took them up again with new vigour only after 1930. He gave up teaching at the Dresden Academy and travelled to Blomay, Venice, Florence, Vienna, where his father died, and Paris, painting his Swiss landscapes, *Florence* (bought by the Kunst-halle in Hamburg for 7,000 marks), *Venice, Boats at the Dogana,* the portrait of Arnold Schönberg (in 1914 he had painted one of Anton von Webern) and the one of Nancy Cunard. One-man shows were put on at the Gallery Goldschmidt-Wallerstein in Berlin, the Gallery Goltz in Munich and the Neue Galerie in Vienna. For the whole of 1925, thanks to a favourable contract with Cassirer, he travelled in France (Bordeaux, Biarritz, and after a stay in Vienna, Avignon, Marseilles and Monte Carlo), and in Spain and Portugal. He also visited London and Amsterdam. Meantime, in Dresden (Arnold Gallery), Hanover (Kestnergesell-schaft), and Berlin (Cassirer) he had one-man shows. In the summer he exhibited ten works at the Internationale Ausstellung in the Kunsthaus in Zürich. Westheim's monograph was published by Cassirer in a second (enlarged) edition and a more serious study by Grohmann on the drawings of Kokoschka's early period was also published; indeed, his work was given a great deal of attention during the year. Apart from a few drawings and the etchings for *Mach die Tür zu, es Zieht* by Bohuslav Kokoschka, he worked almost entirely at painting: *The Theatre at Bordeaux, The Beach at Biarritz,* French and Spanish landscapes, English and Dutch views, the portrait of Kraus (II), etc. etc.

At the end of the summer of 1926 Paul Cassirer died in Berlin, while Kokoschka was in London, painting a great many pictures: *Waterloo Bridge, Richmond Terrace, The Lion,* a portrait of Adele Astaire etc. Back in Berlin in the autumn he painted *The Brandenburg Gate* and started the portrait of Temary. In Kassel, *Orpheus und Eurydice* was first put on by Ernst Křenek; in Frankfurt, at the Kunsthandlung Goldschmidt, and in Munich at the Gallery Caspari, Kokoschka had one-man shows. Seven of his paintings were also shown in June at the International Art Exhibition in Dresden.

In 1927 he was in Paris again, where he was in touch with Pascin; then, after a stay in Venice, he visited Courmayeur, Chamonix, Annecy and Lyon and then went back to Paris. Among other pictures, he painted the first two views of the Salute and the impor-tant picture *Lyon.* In February, Cassirer's heir put on a one-man show of Kokoschka's work at his gallery under the title *Menschen und Tiere* ('Men and Animals'). At the end of June there was a large exhibition at the Kunsthaus in Zürich, including over a hundred paintings, about five hundred drawings and watercolours, and more than a hundred graphic works; the catalogue's preface was by Wartmann. In October the Kunsthaus Schaller in Stuttgart exhibited twelve paintings. Between 1927 and 1928 a travelling exhibition of Kokoschka's work went round the main cities of Holland.

The paintings *El Kantara, Marabout,* and *Exodus* were the result of a voyage Kokoschka made to North Africa (Tunisia and the Sahara) in 1928; he also began *The Market in Tunis,* which he completed the following year. Back in Paris he continued painting, alternating between oils and watercolours. In June he had a one-man show at the Leicester Gallery in London. In the same year thirteen of his works were shown at the National Gallery in Berlin for the exhibition Neuere deutsche Kunst aus Berliner Privatbesitz.

In 1929 he continued to travel: in Ireland, Scotland, Egypt, Turkey and Palestine. His base was in Munich. Short essays on Kokoschka by Biermann and Heilmaier appeared, and a piece on him in the *Encyclopedia Britannica.* A one-man show was put on at the Kunsthaus Hermann Abels in Cologne in March. He painted landscapes in Scotland and the Near East and in Munich the portrait of Marcel von Nemeš.

In 1930 he was still travelling: to Paris, Vienna, Algiers, Anticoli,

(Italy), Annecy and Paris again. In Italy he painted *Algérienne au Tonneau* and *Anticoli*.

In 1931 Kokoschka had important one-man shows in Mannheim (Kunsthalle) and Paris (Gallery Georges Petit), and the prestigious exhibition at Frankfurt, *Vom Abbild zum Sinnbild* (From Figure to Symbol), established him as one of the most important European painters. Those who wrote on his painting included Kerr, Schönberg, Loos, Liebermann and Hildebrand. 'Geschichte der Schmieden' was published in the *Kunstblatt* and the story 'Die Mumie', which was later rewritten, appeared in the *Frankfurter Zeitung*. Once again Kokoschka became interested in graphic art, and he illustrated Erhrenstein's *Mein Lied* ('My Song') and made many pencil and chalk drawings. The international slump however, brought him quite serious financial troubles. His contract with Cassirer's heirs was not renewed and he retired to his own small house in the Liebhartstal in Vienna. The town council commissioned the great canvas *Vienna: View from the Wilhelminenberg*, which pays a kind of homage to Bruegel.

In 1932, Kokoschka exhibited twenty-seven works, both paintings and drawings, at the XVIII Venice Biennale and the pro-Nazi press began a violent campaign against his work. He moved to Paris again and probably travelled to Genoa and Venice. He painted landscapes and *Self-portrait with a Cap*. He also did many drawings in red pencil.

1933, the year in which Hitler came to power in Germany, was a very difficult year for Kokoschka. Serious financial troubles made him leave Paris, and after a stay in Rapallo as Visser's guest he returned to Austria. In Vienna he painted some still-lifes and *Landscape with a Young Girl*; he also did some drawings and the lithograph *Girl in a Straw Hat*. A letter from Thomas Mann in *Der Wiener Kunstwanderer* recognised the value of his work. In December the Feigl Gallery in Prague gave a one-man show, which included the landscapes he had painted at Rapallo.

By 1934 the political situation in Austria had become extremely difficult. After a visit to Budapest, Kokoschka settled in Prague. There he drew and painted landscapes, among them *The Moldavian Woman* with trees in the foreground, and wrote the autobiographical story *Verwundung* ('Wounding'). In the same year his mother died.

In 1925 Kokoschka met Olda Palkovská, who was to become his wife, and started the portrait of the old Bohemian president Thomas Masaryk. The friendship which resulted between him and Masaryk allowed him to study his model in depth, through pencil sketches and long conversations. A subject that interested them both was the work of the great Moravian educationalist Jan Amos Comenius, and from this was born the portrait of Masaryk with an allegorical figure behind him (an ideal portrait of Comenius). Kokoschka also painted some important views of Prague: *The Charles Bridge, Prague: View from the Schönborn Gardens* etc. He started on the play *Comenius* and in Berlin Ernst Rathenau published a collection of 127 drawings with an autobiographical introduction. The publication was seized by the Nazi authorities, who had already forbidden the publication of Westheim's preface to his *Handzeichnungen* ('Free-hand Drawings'). More than twenty of Kokoschka's paintings were shown in the important exhibition at the Kunsthaus in Zürich in April 1925.

In 1936 he finished the portrait of Masaryk, painted views of Prague, drew enthusiastically, worked on *Comenius* and wrote about teaching and about himself.

In 1937 he was given a large one-man show at the Österreichisches Museum für Kunst und Industrie in Vienna, and in the summer nine of his paintings were shown to the public as examples of 'degenerate art' at the exhibition in Munich entitled Entartete Kunst. He was harshly attacked in the German press, and it must be remembered that he had painted obviously provocative pictures (for instance, *Self-portrait of a 'Degenerate Artist'* and the lithographs *Help the Basque Children*, *García Lorca* and *La Passionaria–Dolores Ibarruri*). While political tension grew (the Civil War in Spain, the armaments race in Germany and Italy, racial persecutions, cultural ostracism), more than 400 of Kokoschka's works were removed from public collections as 'typical examples of degenerate art'.

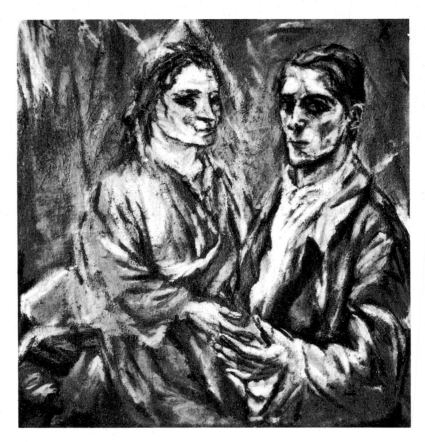

43 *Self-portrait with Alma Mahler*
1912–13, oil on canvas
$39\frac{1}{4} \times 35\frac{1}{2}$ in (100 × 90 cm)
Private collection,
Hamburg

Events in Germany hurried on: after the Munich pact in September 1938 Kokoschka had to leave Prague (where he had painted *Reclining Nude* and finished *The Spring*) and fled to London with Olda Palkovská, where his financial state was disastrous. The Buchholz Gallery in New York organised a one-man show. Recent works of his were shown in the International Exhibition of painting at the Carnegie Institute in Pittsburg. In London he painted *Nostalgia for Prague*.

Throughout 1939 his material and spiritual troubles persisted, and when the Second World War broke out they became worse. He moved to Polperro in Cornwall, where he painted a number of landscapes. His first paintings with political allusions belong to this period, as well as the portraits of the Croft family. In February he had a one-man show at the Genootschap Kunstliefde in Utrecht, and a group of his works was included in an exhibition of Modern German Art at the Museum of Fine Arts in Springfield. Nine of his paintings rejected by German museums were shown in the Fischer Gallery in Lucerne (Gemälde und Plastiken moderner Meister aus deutschen Museen, Paintings and Sculpture by modern artists in German museums).

In the summer of 1940 he had to return to London, and once again drew and took up the technique of watercolour. He started painting *The Red Egg* (the first openly political work of his which he finished in 1941) and worked on *Comenius*. Hodin's essay, 'Kokoschka, Målare och Humanist' ('Kokoschka, Painter or Humanist') appeared in Stockholm in the review *Konstrevy*. At the St Etienne Gallery in New York he had a one-man show.

In spite of the bombing and the troubles of war Kokoschka worked busily throughout 1941; he painted watercolours (flowers) and wrote the essay *Comenius, the English Revolution and our Present Plight* (published the following year with other political writings). He had one-man shows in Chicago (Art Club) and New York (Buchholz Gallery).

In 1942, after a trip to Scotland, where he painted *Scottish Coast*

(Fort William), he returned to London, where he became intensely busy with teaching and political propaganda. Even his drawings *(Alice in Wonderland)* reflected this. In October he had a one-man show at the City Art Museum in St Louis. Many of his works had been exhibited some months earlier at the Demotte Gallery in New York, in the exhibition called Czechoslovak Contemporary Art. In Italy a monograph by Michelangelo Masciotta (published by Parenti, Florence, 1942), was immediately seized by order of the Fascist regime, and only a few copies survived. Kokoschka was commissioned to paint a portrait of the Russian ambassador in London, Ivan Maisky; Ludwig Goldscheider *(Kokoschka,* Phaidon Press, London, 1963) remarks of it that 'The picture's background includes a symbolic hint of the dangers of Russian imperialism, a prophecy that remains unnoticed.' Kokoschka received £1,000 for the portrait of Maisky, an enormous sum at the time; but he gave it at once to the International Red Cross for the benefit of Russian and German soldiers wounded at Stalingrad. His financial condition was so bad that he had to economise even on canvas and paints.

For the whole of 1943 he was busy lecturing, and writing essays and articles on the 'rebuilding of German culture' (he was president of the Free German League of Culture). He finished his portrait of Maisky and painted works which were explicitly political *(What are we fighting for?).* He had a one-man show at the Gallery St Etienne in New York.

In 1944, during a summer holiday in Scotland, Kokoschka painted, among other things, *The Hunters* and did many pencil drawings and watercolours of landscapes, figures of men, animals and plants. His cultural and political work was unceasing. Among other things, he published essays on Expressionism and on the Bohemian Baroque. At the exhibition *Der Sturm* at the Kunstmuseum in Berne, he showed twenty works.

In 1945, immediately after the War, Vienna sought to repay its own great debt to Kokoschka by exhibiting over twenty of his graphic works, but the show made no impression on the Viennese, who failed entirely to understand their most important modern painter. 'In this, OK's first exhibition ["Klimt, Schiele, Kokoschka", Neue Galerie, Vienna, September–November 1945] in Vienna in eight years, his works are hung side by side with hysterical drawings by Schiele, as though the two artists were peers.' (L. Goldscheider op. cit.). Meantime Kokoschka wrote *A Petition from a Foreign Artist to the Righteous People of Great Britain for a Secure and Present Peace* published two years later in an appendix to the large monograph by E. Hoffman, and, in *Apropos,* he published a theoretical essay on portraiture. In the same year Hodin published important articles on Kokoschka's politically inspired paintings and Neumeyer published an article in the *Magazine of Art.* Kokoschka spent most of the year in London, with a short summer stay at Ullapool, where he was busy with humanitarian activities: at his own expense he published a lithograph appealing for child victims of the war *(Christ from the Cross Bending Down over Suffering Children).* He worked on the portrait of Cathleen, Countess of Drogheda (finished later) and finished *Minona, Threnody,* and *Ullapool–landscape.* It was found that his works which had been seized by the Nazis and deposited in Berlin had been destroyed.

Throughout 1946 he made a large number of watercolours, but painted very little in oils. He travelled a little and wrote the essay 'Ein Deutscher Künstler in England' ('A German Artist in England'), which later appeared in *Bild, Sprache und Schrift* ('Image, word and writing'). Platschek's monograph on Kokoschka appeared in Buenos Aires. At the end of the year, the International Exhibition of Modern Art, in which Kokoschka's works were among the most significant, opened at the Musée Nationale d'Art Moderne in Paris.

In 1947 he became a British citizen. In March he was in Switzerland for the great Exhibition of his works at the Kunsthalle in Basle (260 works, including drawings, lithographs, watercolours and oils). The exhibition aroused great interest among the public and in the international press. In London Edith Hoffman's *Kokoschka, Life and Work* (Faber and Faber) appeared. Kokoschka gave a lecture on the theme *Bild, Sprache und Schrift,* wrote for the *Neue*

Zürcher Zeitung ('Die Geschichte der Tochter, Virginia' – 'The Story of the Daughter, Virginia') and for the review *Atlantis.* He stayed in Switzerland until the autumn and there painted many landscapes *(Matterhorn I* and *II, Montana, Leuk* and *The Rhone Valley,* etc.), as well as a portrait of Werner Reinhart, brother of the art collector Oskar Reinhart, famous patron of poets and musicians, and industrialist in Winterthur. Back in London he painted a portrait of Valerie Goulding. At the Kunsthaus in Zürich and the Stedelijk Museum in Amsterdam he had one-man shows.

At the XXIV Venice Biennale in 1948 there was a special exhibition of Kokoschka's works (sixteen of them). He stayed in Venice *(Santa Maria della Salute III, Bacino of St Mark)* and in Florence *(The Duomo, Self-portrait at Fiesole, View of Florence from the Magnelli Tower, Portrait of the Archbishop Elia Dalla Costa).* Many articles on him appeared in Italian newspapers and magazines. His *Landschaften* ('Landscapes') and *Blumenaquarelle* ('Watercolours of Flowers') were published, by, respectively, Westheim and Doris Wild. An important exhibition that included 126 of Kokoschka's works, paintings, sculpture and graphic art, was shown in Boston (Institute of Contemporary Art) and in Washington (Phillips Memorial Gallery) and thus spread a knowledge of his work in the United States. By enlarging the catalogue of this travelling exhibition, James Plaut produced a book on Kokoschka which was published in England and the U.S.A. (two original lithographs appeared as an appendix to it).

In 1949 the exhibition was taken to St Louis (The City Art Museum), San Francisco (M. H. De Young Memorial Museum), Wilmington (Society of the Fine Arts Galleries) and New York (Museum of Modern Art), where, in February, the Feigl Gallery had shown fourteen unpublished watercolours. Many articles and critical pieces appeared in the American press, in both newspapers and periodical reviews, after these exhibitions. Meantime, after a stay in London, Kokoschka went to Vienna *(The Mayor Körner)* and to Rome *(The Roman Forum, The Colosseum);* then to Minneapolis *(Mr and Mrs Cowles)* and to Boston, where he gave a series of classes. Michelangelo Masciotta's monograph on him was published in Florence by Del Turco, and fifty copies included an original etching, *Portrait of Olda.*

For the first seven months of 1950 Kokoschka worked in London on his great triptych in tempera, *The Myth of Prometheus,* commissioned by Count Antoine Seilern. Then he went to Salzburg where he painted a view of the old city; to Munich for the exhibition at the Haus der Kunst (it later went on to the Kunsthalle at Hamburg and the Kunsthalle at Mannheim); to Frankfurt, after a brief stay in Italy, for the production of *Orpheus und Eurydice;* and to Victorshöhe (Bonn) to paint a portrait of Theodor Heuss. At the end of the year he returned to London. Among writings on Kokoschka that appeared in 1950 were those of Hodin in *Der Monat,* of Arntz in the catalogue for the Haus der Kunst *(Notes on Oskar Kokoschka,* New York, 1950) and Argan (now in *Studi e Note,* Rome, 1955).

At the beginning of 1951, Kokoschka painted a portrait of Isepp, and in May, in Hamburg, one of the mayor, Max Brauer. He also painted *View of the Port from the Tower of the Institute B. Nocht,* and *Self-portrait with Chinese Shadows.* He then visited Switzerland and Italy *(Santa Maria della Salute, IV).* At the end of the year, in Zürich, he started the portrait of Emil Bührle (finished in 1952). Earlier he had made the lithographs *Leda* and *The Magic Form* which illustrated the poems of Berta Patockova, published by Gurlitt. *Orpheus und Eurydice* was performed in Hamburg, and Kokoschka had one-man shows in Berlin (Schloss Charlottenburg), Cologne (Wallraf-Richartz Museum), and Linz (Neue Galerie der Stadt). He wrote on Van Gogh and Arcimboldi, and important critical essays on him were written by Wingler, Westheim and Thwaites.

The XXVI Venice Biennale in 1952 gave a room to Kokoschka (his works shown included *The Myth of Prometheus).* He spent a long period in Switzerland, when he painted portraits of the Feilchenfeldt brothers and of Bettina Angehrn. He went to Hamburg to receive the Lichtwark prize and then to Minneapolis: here he gave a series of lessons at the local art school and painted a portrait of Pete Gale. He was drawing a great deal and made several litho-

graphs (*The Hare, The Fox and the Grapes* etc.); he published the story *Ann Eliza Reed*, with lithographs; for *Das Werk*, he wrote an article on Prometheus and for the *Neue Zürcher Zeitung* a short essay on Munch. With a careful introduction by Paul Westheim, *Gestalten und Landschaften* ('Figures and Landscapes') appeared in Zürich, published by Rascher. In the autumn, the Institute of Contemporary Arts in London had a one-man show, with more than a hundred works (graphic works and watercolours).

In July, 1953, Friedrich Welz founded the Internationale Sommerakademie für bildende Kunst at Salzburg; there Kokoschka ran the Schule des Sehens (School of seeing) in which he put into practice principles of learning which he worked out according to a precise didactic system through the long years in which he had observed reality. Meantime, he continued with his work as a portrait painter; in Switzerland he painted a portrait of Gubler and in London that of a young aristocratic girl (*Galatea*); he designed a series of sketches for the triptych *Thermopylae* in coloured chalks. In Salzburg he made a series of nudes, a group of watercolours (particularly flowers) and the lithograph *Gitta Welz*. In the *Neue Zürcher Zeitung* he published 'Bemerkungen zum Kunstunterricht' ('Observations on the Teaching of Art'). He was represented in the exhibition Deutsche Kunst–Meisterwerke des 20. Jahrhunderts (German art–masterpieces of the 20th century), at the Kunstmuseum in Lucerne. He had one-man shows in Oslo (Kunsternes Hus) and Frankfurt (Frankfurter Kunstkabinett). At the end of the summer he went to Switzerland with his wife Olda, and settled in Villeneuve on lake Geneva.

In 1954 he worked fervently on his triptych *Thermopylae*. During a visit to London he painted a new version of his *Landscape of the Thames* and *The New Waterloo Bridge*, and a portrait of Pablo Casals. In the summer he taught at Salzburg. He published essays on the Academy of Salzburg (*Zeitschrift Universitas*) and on 'Gegenstandslose Kunst' (non-objective art) (*Das Werk*). Wingler published *Künstler und Poeten* ('Artists and Poets') (Buchheim, Feldafing), in which ample space was given to Kokoschka. The Museum of Art in Santa Barbara and the Californian Palace of the Legion of Honour of San Francisco showed a collection of twenty-two paintings. Other one-man shows were held in Rio de Janeiro (Museum of Modern Art), Salzburg (Galerie Welz), Freiburg (Kunstverein) and New York (Gallery St Etienne).

In 1955, at Villeneuve, he finished *Cupid and Psyche* and painted the portrait of Topazia Markevitch. After a journey to Linz (*The Danube and Linz*), he went to Salzburg for his usual teaching at the Sommerakademie and to continue working on costumes and scenery for *The Magic Flute* at the Mozart festival there. (He obtained this work through Furtwängler and Dr Klaus, and after a great deal of discussion came to agree perfectly with the producer Graf and the man responsible for the scenery, Gustav Vargo.) In the autumn, at Sion a second Schule des Sehens was set up. The sketches for *The Magic Flute* were reproduced with a text by Kokoschka in a small volume published by the Galerie Welz. A room was given to Kokoschka at an important retrospective exhibition of twentieth-century art at Kassel (*Documenta*). One-man shows were held in Salzburg (Residenz) and in Vienna (Secession).

In 1956 Kokoschka was seventy: greetings came from all over the world and he was given a high honour by President Heuss. He continued to work enthusiastically: he finished *Androcles and the Lion* and *The Two Girls*. At Glion (Montreux) he painted *Glance at Lake Geneva* and in Vienna he was commissioned by the Austrian Minister of Education to paint *The Opera in Vienna*. In April he went to Greece and found new inspiration (*Delphi* and *The Bay of Ithea*): 'The art of Greece' as L. Goldscheider wrote, 'which has always played a significant role in his imagination, now reigns supreme . . . The monumental paintings on which he is presently working [at the beginning of the sixties] testify to the overpowering impression the landscape and the art of Greece have left on him.' (op. cit.) In 1956 he also made coloured lithographs (*Self-portrait, Two Girls, Cupid and Psyche*). The essay *Das Auge des Darius* ('The Eye of Darius') appeared, and *Schriften 1907–1955* (edited by H. M. Wingler, A. Langen-G. Müller, Munich). One-man shows took

place in Prague (Národni Gallery) and at Bremen (Kunsthalle). The most important publications that appeared in this year about Kokoschka are: R. Netzer, *Oskar Kokoschka–Lithographien*, (Piper Verlag, Munich); H. M. Wingler, *Oskar Kokoschka–Das Werk des Malers* (Galerie Welz, Salzburg), a fundamental work for the dating of paintings up to 1956; H. M. Wingler, *Oskar Kokoschka– Ein Lebensbild in Zeitgenössischen Dokumenten*, (A. Langen-G. Müller, Munich).

In 1957, a monograph appeared by H. M. Wingler (*Kokoschka-Fibel*, published by Galerie Welz, Salzburg). Bernard S. Myers' *Expressionism* was published devoting much space to Kokoschka's life and work. Four important works by Kokoschka were included in the exhibition German Art From 1905 Until Today, organised by the Quadriennale Nazionale d'Arte di Roma and the Ente Manifestazioni Milanesi, in collaboration with the Haus der Kunst of Munich. W. Grohmann wrote the introduction to the catalogue.

Three large one-man shows took place in 1958. In March, 431 of Kokoschka's works were shown at the Haus der Kunst in Munich (this was reviewed in *Sele Arte*, number 36, 1958); in May, there was an exhibition at the Künstlerhaus in Vienna (catalogue with preface by F. Schmalenbach); in July at the Gemeentemuseum at The Hague (catalogue with a preface signed L. W.).

Throughout the whole of 1959 Kokoschka travelled and worked busily; among other things he painted a *View of the Thames*. The Ente Premi Roma organised an important exhibition of his work at the Palazzo Barberini. On this occasion an excellent, well-documented catalogue was published, with introductory essays by Michelangelo Masciotta and Jacopo Recupero.

In 1960 Kokoschka painted a portrait of Israel Sieff and *Cherry Branch* (a delicate watercolour). In No. I of *Arte Figurativa*, Marisa Volpi wrote on the exhibition of Kokoschka's work in the Palazzo Barberini.

In 1961 Westheim's *Kokoschka* appeared.

In 1962 Kokoschka painted a portrait of Rudolf Palumbo in oils, and made drawings of Ezra Pound and Veska. He designed the scenery and costumes for the Florentine production of Verdi's *Un Ballo in Maschera*. The Tate Gallery in London gave a large exhibition of his work; 300 works from 1907 to 1962 (catalogue edited by E. H. Gombrich, F. Novotny and H. M. Wingler). In the October number of *The Studio* P. J. Hodin published his essay 'O. Kokoschka, a Seer in our Time'. In *Apollo*, number 7, an article by F. Novotny appeared: 'O. Kokoschka as a Draughtsman'.

In October 1963, Wolfgang Fischer interviewed Kokoschka at the Hyde Park Hotel in London. The text of the interview was published in the catalogue of the exhibition of the lithographs *Hellas, Apulian Reise*, and *König Lear* (sixty-three lithographs in all, from 1961 to 1963), at the Marlborough Gallery in London. The Phaidon Press in London published *A Colloquy between Oskar Kokoschka and Ludwig Goldscheider*. Kokoschka painted a portrait of Mrs Ralda Nash.

In 1964 he finished a work he had begun in 1955 (*Two Girls*) and apart from designs for *The Magic Flute* he produced some watercolours: *Tree and Lake, Roses*. At the Palazzo Strozzi in Florence an exhibition called Expressionism was put on, and included some important works by Kokoschka (biographical note in the catalogue by M. Volpi). The review *Marcatré* (numbers 8, 9 and 10, July-August-September, 1964) published an interesting article by G. C. Argan, who considered Kokoschka the inventor of the 'destructive portrait. The portrait as *murderer*: what dies here', he wrote, 'to give life to authentic existence, is the conventional figure of the sitter'.

Throughout the whole of 1965 Kokoschka did more watercolours (flowers and fruit), drawings (dropcloth for *The Magic Flute*) and lithographs (*The Odyssey, Self-portrait* etc.). As general appraisals of Kokoschka's work, L. Mittner's book *L'Espressionismo*

44 Photograph of Oskar Kokoschka

(Laterza, Bari, 1965) and D. Durbé's essay 'L'Espressionismo', in *Arte Figurativa*, numbers 2 and 3, 1965 are worth reading.

In 1966 the Kunsthaus in Zürich celebrated Kokoschka's eightieth birthday with a large exhibition (works from 1907 to the recent portrait of Adenauer). The *Notiziario d'Arte* of July-August wrote of the exhibition: it 'has a very special value in that, since 1913, the Kunsthaus in Zürich has exhibited paintings by the then almost unknown painter and in 1927 put on his large one-man show . . . Opinions are divided about the latest period . . . but the works of the earlier period, paintings, drawings or prints, are quite beyond discussion; as Gisela Fehrlin says, they have already become a part, in the best sense, of the history of art.' In 1966 Kokoschka painted *View of Manhattan with the Empire State Building, Berlin, 13th August, Saul and David, The Rejected Lover, Portrait of a Woman* (lithograph), and made eighteen lithographs of *Marrakesh*. In March, the Marlborough Gallery in London put on an exhibition, *Homage to Kokoschka* (catalogue with a text by Wolfgang Fischer), and the Arts Council an exhibition of lithographs. In Vienna, Kokoschka published *Die Wahrheit ist unteilbar* ('Truth is Indivisible').

In 1967, at the Marlborough Gallery in London, Kokoschka had another one-man show. He was still active: he painted *London, the Houses of Parliament* and *Girl with a Bunch of Flowers* (watercolour). In the autumn he made the nine lithographs of London from the river Thames and the five lithographs of *Manhattan 1966–67*. He also made many watercolours (flowers in particular) and seven lithographs for *Le Bal Masqué*, with a French text by Marcel Jouhandeau. The third volume of *L'Arte Moderna* appeared (Milan, Fratelli Fabbri); Werner Hoffmann, in *Expressionism in Austria*, gave a critical interpretation of Kokoschka's contribution to the Expressionist movement.

In 1968 he painted *The Sailor's Wife* (oil), *Bird and Serpent* (watercolour), *Flowers* (coloured chalks), *Tortoises* (watercolour) etc., as well as twelve drypoint engravings to illustrate *The Frogs* of Aristophanes. E. Huttinger published an article on Kokoschka in the November number of *Universitas*. F. Schmalenbach's *Oskar Kokoschka* (Königstein, Taunus, 1968) also appeared.

In 1969, from March until May, another one-man show was held at the Marlborough Gallery in London. Kokoschka painted *The Frogs* and *Self-portrait,* and made the lithographs for *Saul and David*. A short monograph by A. Bosman appeared, *Kokoschka* (Blandford Press, London, 1969).

On March 1st 1971, Kokoschka was eighty-five: he has not stopped painting.

Bibliography

Nearly all the significant works on and by Kokoschka have been mentioned in the preceding biography. Almost complete information can be found in the monograph by H. M. Wingler (Welz, Salzburg, 1956), in the catalogue of the exhibition organised by the Ente Premi Roma (De Luca, Rome, 1959) and in the bibliographical indexes of volumes III and XII of *Arte Moderna* (Fratelli Fabbri, Milan, 1967 and 1970). Among the many works on Expressionism, outstanding for their historical insight and critical depth are T. H. W. Adorno's *Philosophie der Neuen Musik* (J. C. B. Mohr, Tübingen 1949), L. von Rognoni's *L'Expressionismo e Dodocafonia* (Einaudi, Turin, 1954), B. S. Myers *Expressionism* (1957), and L. Mittner's *L'Espressionismo* (Laterza, Bari, 1965). Two important essays should also be consulted: G. C. Argan's 'L'Estetica dell'Espressionismo' in *Marcatré*, numbers 8, 9 and 10, July-September, 1964, and 'Espressionismo: Pittura e Cinema' in *Bianco e Nero*, September-October, 1968.

OVER NIGHT BOOK

This book must be returned before the
first class on the following school day.

DEMCO NO. 28-500

RB Gatt, Guiseppe 756327
750 Kokoschka
Gat

756327

RB Gatt, Giuseppe
750 Kokoschka
Gat

ISSUED TO

DATE

Fac. Bernardi fac
9/30 Bernardi OFAC
5/8 Ernestine Hope CBD
 Bill Harper
11/10/80 Lanne CM DBZ